PAIRING OF POLARITIES

PAIRING of POLARITIES

THE LIFE AND ART OF SONYA RAPOPORT

EDITED BY TERRI COHN

With additional essays and interviews by Richard Cándida Smith; Anna Couey and Judy Malloy; Ernestine Daubner; Walter H. Moos, Susan M. Miller, & Sarah R. Moos; Hava Rapoport; Meredith Tromble; Anuradha Vikram; and John Zarobell

Afterword by Roger Malina

Heyday, Berkeley, California

I dedicate this book to my family, who is constantly by my side: my late husband, Henry, and our children, Hava, David, and Robert; and to our beautiful granddaughters, Sonia, Sol, Ayla, Dena, and Dahlia. —*Sonya Rapoport*

I dedicate this book to my daughters, Zoe and Leah, with love and gratitude for their remarkable creativity, intelligence, and unwavering support; and to my father, Howard, and my late mother, Velma, who have always believed in me. I also dedicate this book to Sonya Rapoport, for the years spent sharing her *Gesamtwerk* with me. The project is much greater than the sum of its parts. —*Terri Cohn*

Library of Congress Cataloging-in-Publication Data

Pairing of polarities : the life and art of Sonya Rapoport / edited by Terri Cohn ; with additional essays and interviews by Richard Cándida Smith ...[et al.] ; afterword by Roger Malina.
 p. cm.
Includes bibliographical references and index.
ISBN 978-1-59714-187-1 (pbk. : alk. paper)
 1. Rapoport, Sonya--Criticism and interpretation. I. Rapoport, Sonya. II. Cohn, Terri. III. Cándida Smith, Richard. IV. Malina, Roger. V. Title: Life and art of Sonya Rapoport.
N6537.R24P35 2012
709.2--dc23
 2011043977

Front Cover image: Sonya Rapoport, *Surface, Isomorphics* series (from *Objects on My Dresser*), 1981. Portrait originally by Adolphe Braun, Countess Castiglione, c. 1860.

Book design by Lorraine Rath

Orders, inquiries, and correspondence should be addressed to:
 Heyday
 P.O. Box 9145, Berkeley, CA 94709
 (510) 549-3564, Fax (510) 549-1889
 www.heydaybooks.com

Printed in Korea by Everbest Printing Co. through Four Colour Imports, Ltd., Louisville, Kentucky

10 9 8 7 6 5 4 3 2 1

Contents

Preface

Terri Cohn

I first experienced Sonya Rapoport and her work as part of an Art, Technology, and Culture Colloquium lecture she gave at the University of California, Berkeley, in November 2004. Meredith Tromble, a fellow writer and colleague at the San Francisco Art Institute (and contributor to this book), invited me to attend the ATC lecture. She knew that Sonya was looking for someone to think with her about her art and life, and to plan various projects—a career survey exhibition and a monograph, among others—and thought that I might be the right person to fill these roles. Sonya's talk that evening, which began with her iconic statement "Having survived Art 2A, I eventually landed in Cyberspace," immediately intrigued and amused me. When we met after the lecture and she graciously invited me to visit her at her studio, I agreed to call and make an appointment to do so. Little did I know how predictive that experience would be, and what worlds would open up through the experience.

I spent more than a year, during 2005 and 2006, meeting weekly with Sonya in her studio. As we viewed the extensive archives of her work in various static and time-based media—both past and in progress—I became engaged in her personal and unique interest in and approaches to the intersections among art, science, and technology. She shared the extensive writings and texts that she and others have published about her work, and I became involved with editing her work as well as writing about it. These writings included abstracts and bios for various grants and projects in the US and abroad, which enhanced my understanding of Sonya's thinking and development as an artist. During this time I also participated on a panel as part of the Mid-Atlantic Popular and American Culture Association conference in Baltimore, Maryland (2006), for which I prepared a talk about Sonya's *Objects on My Dresser*. At her request, I also took part in an oral history project—organized and led by Richard Cándida Smith (also a contributor to this book)—which focused on how Sonya's graduate education at UC Berkeley's art department during the late 1940s influenced her artistic development. These various experiences collectively immersed me in the

remarkable spectrum of creative thinking and approaches Sonya has applied to her art making over more than a half century, and excited my interest in new media and interactive approaches to art making, which were already central to the twenty-first-century contemporary artistic lexicon. At the time, the intersections between art, science, and technology were exciting and sometimes baffling, and Sonya's long involvement in them was a great impetus for me to become more effortlessly conversant with the breadth of work and writing in this area, which was just becoming common parlance in the American art world. The rest, as they say, has been history.

During that early phase of our work together, when I spent the better part of a day each week working with Sonya in her studio, we laid the groundwork for this book. After countless hours talking about writers, artists, themes, histories, theories, media, and the many disciplines and genres that inform Sonya's art—anthropology, chemistry, botany, religion, psychology, gender, politics, science, technology, transculture, and domestic life, among others—we agreed on an initial list of writers to contribute essays. Over the next two years, as our individual and collective thinking evolved, the group of writers was modified a bit to include the historians, curators, scientists, and artists whose words fill the pages of this book.

The process of conceiving the structure for the book was a foray into Sonya's highly conceptual, associative world, as she has consistently continued to form connections between the myriad facets of life—at times playful or downright humorous, at others uncommon or disturbing—and their expression through a gamut of artistic approaches. It was during that period of brainstorming, philosophical consideration, and a great deal of research that I also realized how Sonya's eclectic interests and cerebral approaches to her work are naturally linked by her deep and consistent interest in systems. Although systems govern our lives on every level, it is ironic that relatively little has been written about the systems facet of Conceptual art. This book provides the opportunity to consider the various disciplinary perspectives on systems—scientific, technological, artistic, relational, and sociopolitical, among others—which the contributors discuss in connection with Sonya's artistic thinking and realization. My own essay considers their perspectives, and proposes a means to contextualize Sonya Rapoport's work in the context of Systems Conceptual art, which has provided the ongoing opportunity to discover the pairings of polarities that epitomize her life, worldview, and art.

Acknowledgments

Work on this book and two accompanying exhibitions began to take form in 2005, and has involved numerous individuals who contributed to its inception, shape, and ultimately its final form. Special thanks to Meredith Tromble for her vision that I would be the right person to oversee this vast project, and for introducing me to Sonya Rapoport. I have great appreciation for the writers who contributed their texts to this manuscript, and the chance for me to consider multiple points of entry into Sonya's life, thinking, and work through our lengthy conversations and their remarkable insights. Appreciation also goes to Malcolm Margolin, Gayle Wattawa, and everyone else at Heyday for their support in realizing this book; to Anu Vikram for our curatorial collaboration on two exhibitions of Sonya's work during 2011 and 2012; to Archana Horsting and Lauren Davies at Kala Art Institute and Stephanie Hanor at Mills College for hosting the two exhibitions of Sonya's work during the period of the writing, editing, and publishing of this book; to Hava Rapoport for meeting with me during her trips to Berkeley from Spain to visit Sonya over the course of six years; to Therese Tierney, Alla Efimova, Dorothy Washburn, and Neil Smelser for sharing ideas, stories, professional advice, and support over time; and to Anthony Williams for his skillful handling of the arduous process of obtaining image permissions. Special thanks to my friends and family, especially Leah Savitsky for much-needed creative and technical finesse in realizing this manuscript; to Zoe Savitsky for concept and editing input; and to both for countless meals and emotional support throughout the writing process.

In memoriam: I would like to remember my mother, Velma Cohn, for her love and courage in the face of insurmountable physical adversity. —*Terri Cohn*

For the making of this book, I wish to acknowledge my deep appreciation to Meredith Tromble for the introduction to Terri Cohn and to Terri for carrying through the monumental task of researching my artwork, interpreting it, and composing the material into a book. I thank the contributing authors for their conscientious

application to helping realize this accomplishment. To Joni Spigler who has been at my side for almost four years I give many thanks for editing my words and other related tasks; and to Marie-José Sat I extend my appreciation for being on call to tweak images.

I'd like also to acknowledge the help of many friends who are responsible for assisting me in production of my art, sharing ideas, and giving me support throughout these many years: Tom Bates, Clay Debevoise, Robert Edgar, Erle Loran, Judy Malloy, Vance Martin, Sonja Max, Eric Sanchez, Jock Truman, John Watson, Kathryn Woods, Roger Malina and Pat Bentson of Leonardo, and Archana Horsting of the Kala Art Institute; Winifred De Vos and Dorothy Washburn for their inspiring collaborations; friends Nancy Genn and John and Kati Casida, who held my hand and loyally attended my exhibitions over a period of many years; Anuradha Vikram for her invaluable guidance; and in appreciation of their support, my immediate family—my husband, Henry, and our children, Hava, David, and Robert; and my brother, Alan, and my sister, Judy, for their patronage; and my parents, Ida and Louis Goldberg, who had great faith in me.

In Memoriam: I'd like to remember Barbara Lee Williams, Steve Wilson, Ariege Arseguel, and Ernestine Singer for their friendship, support, and unique bravery.

—*Sonya Rapoport*

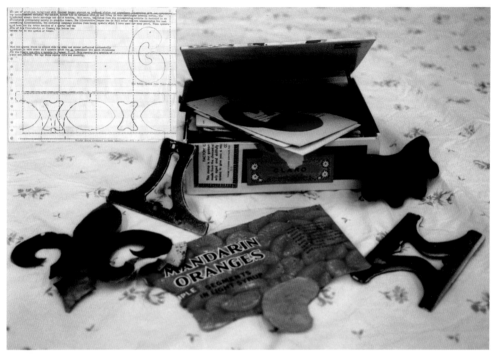

Plate 1
Sonya Rapoport
Pandora's Box, 1962–1972
Diagram (upper left) of application of symbols
Mixed media, cigar box
Dimensions variable

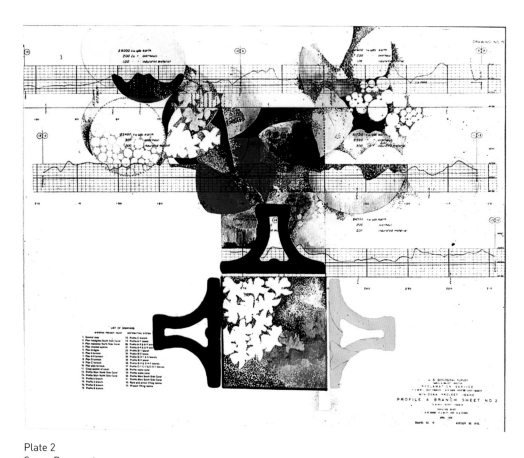

Plate 2
Sonya Rapoport
Survey Chart #15 (Uterus Symbol), 1972
Transfer print and colored pencil on survey chart, 18" H x 22" W
Collection of David Todd Alexander

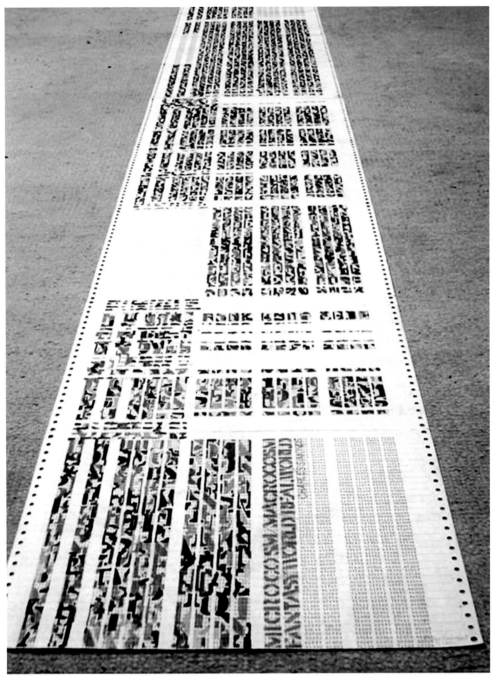

Plate 3
Sonya Rapoport
Charlie Simonds: Microcosm/Macrocosm, 1976
Graphite and colored pencil on continuous computer forms, 99" H x 15" W

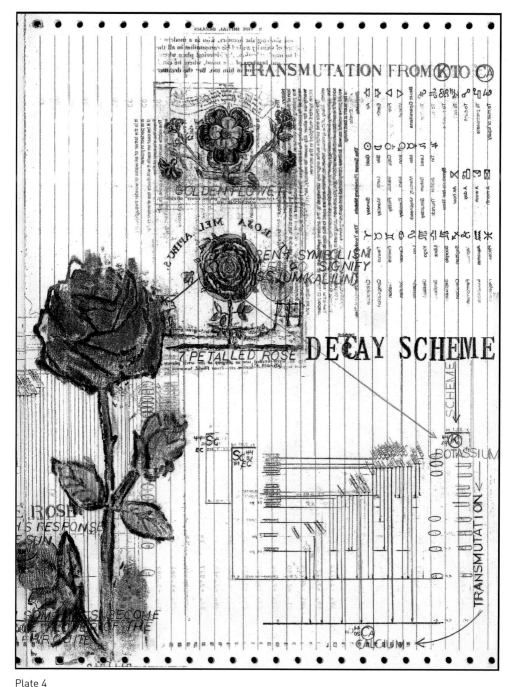

Plate 4
Sonya Rapoport
Cobalt Rose (detail of *Horizontal Cobalt*), 1977
Transfer print and Prismacolor on continuous computer form, 110" H x 15" W

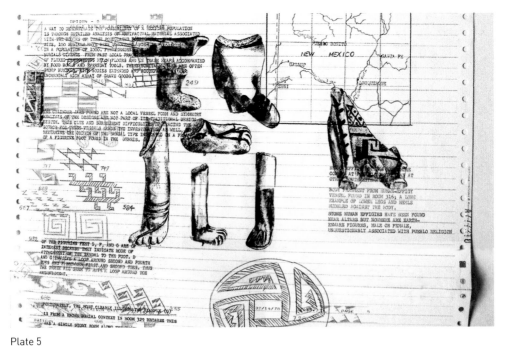

Plate 5
Sonya Rapoport
Foot Effigy Map (detail of *Bonito Rapoport Shoes*), 1978
Transfer print and Prismacolor on continuous computer form containing anthropological research by Dorothy Washburn
110" H x 15" W

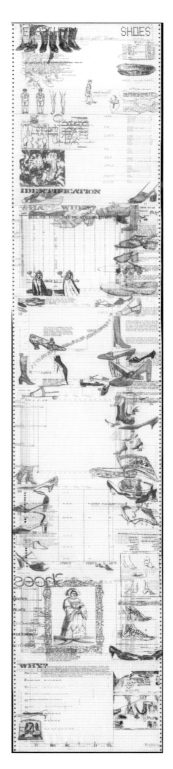

Plate 6
Sonya Rapoport
Bonito Rapoport Shoes (panel 3 with
Rapoport's personal shoes), 1978
Transfer print and colored pencil on
continuous computer forms, 110" H x 15" W

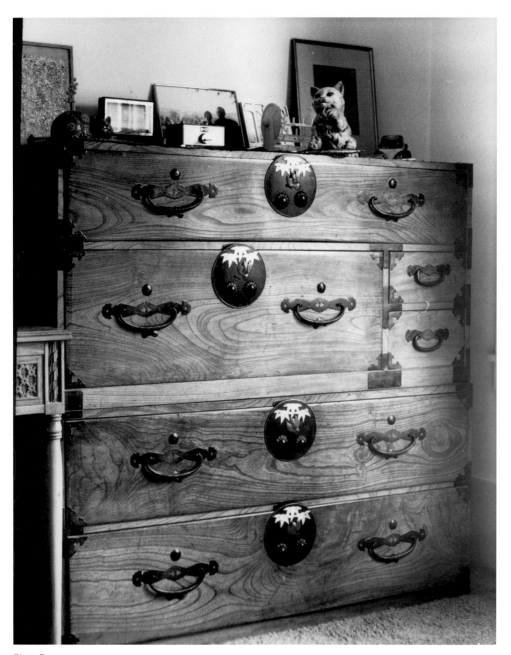

Plate 7
Sonya Rapoport
Objects on My Dresser: Tansu, 1979–83
Tansu dresser in Rapoport's bedroom, with objects on top.

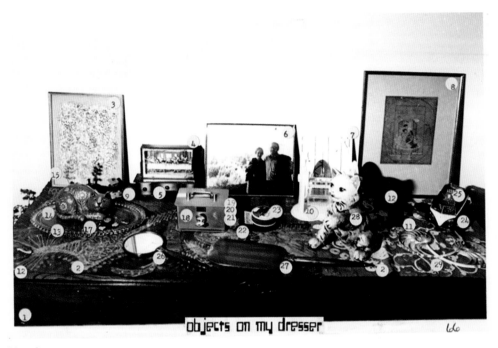

objects on my dresser

Plate 8
Sonya Rapoport
Pictorial Linguistics (from *Objects on My Dresser, Phase 1*), Franklin Furnace, New York, 1979

Rapoport used the 29 objects on her dresser as the basis for this project. To each of the 29 objects she assigned a "correlated object." She next assigned a word to each of the objects and a word to each of the correlative objects. Visual and verbal correlates define this phase.

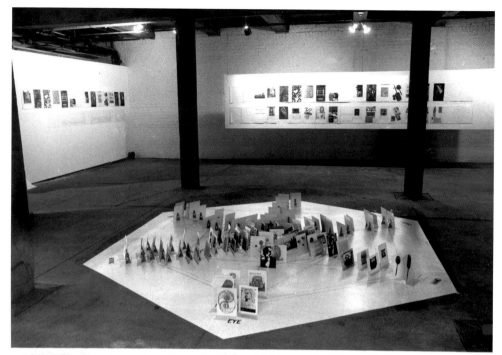

OBJECT IMAGES & ASSOCIATED IMAGES RELATED TO WORD AXES

Phase 2: "Psycho-aesthetic Dynamics", an installation at 80 Langton Street in San Francisco, explored thematic and dynamic analysis of the "objects" and their correlates

Plate 9
Sonya Rapoport
Psycho-Aesthetic Dynamics, 1980 (from *Objects on My Dresser, Phase 2*), 80 Langton Street,
San Francisco, 1980

This installation explored a thematic and dynamic analysis of the "objects" and their correlates.
Collaborator Winifred De Vos, psychotherapist, interviewed Rapoport about her personal image-object selections for word themes. The material evolved into a NETWEB of relationships that Rapoport expressed by placing cards with photocopy images of the objects along six themed radial points: Threading, Masking, Moving, Hand, Chest, and Eye. The data was computerized into spiderweb plot. Audio played discussion between Rapoport and De Vos.

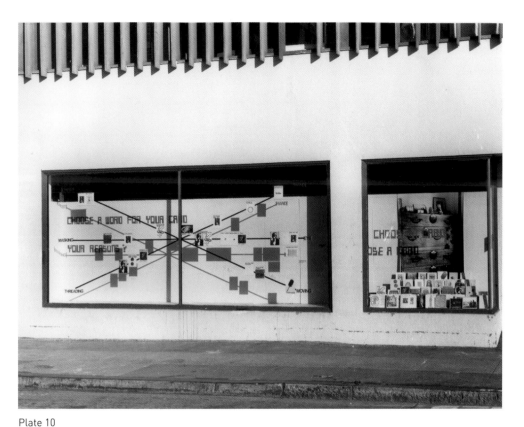

Plate 10
Sonya Rapoport
The Object Connection (from *Objects on My Dresser, Phase 5)*, WINDOW, San Francisco, 1982

Pedestrians respond into adjacent mailbox. Audio of reasons of choices of former participants played into the street.

EYE

"See" is the predominant theme
...among both words and images.

The artist both "sees" and is "seen".
...She sees with mirrors and with eyes.
...She sees others; others see her.
...She sees herself; she sees objects
 ...herself as reflected in mirrors
 ...herself through insight --
 the eye, the "I".
 ..."The Objects on My Dresser"
 ...a personal "universe".

Plate 11
Sonya Rapoport
A 20th Century Portrait (from *Objects on My Dresser, Phase 6)*, Locus, Los Angeles, 1982

An individual's visual-verbal associations comprise data for portrait web plot. Above analysis of Rapoport's profile.

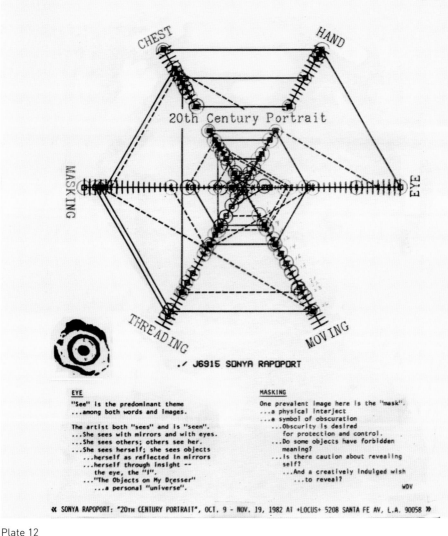

The diagram contains the following text labels:

CHEST HAND

20th Century Portrait

MASKING EYE

THREADING MOVING

./ J6915 SONYA RAPOPORT

EYE

"See" is the predominant theme
...among both words and images.

The artist both "sees" and is "seen".
...She sees with mirrors and with eyes.
...She sees others; others see her.
...She sees herself; she sees objects
 ...herself as reflected in mirrors
 ...herself through insight --
 the eye, the "I".
 ..."The Objects on My Dresser"
 ...a personal "universe".

MASKING

One prevalent image here is the "mask".
...a physical interject
...a symbol of obscuration
 ...Obscurity is desired
 for protection and control.
 ...Do some objects have forbidden
 meaning?
 ...Is there caution about revealing
 self?
 ...And a creatively indulged wish
 ...to reveal?

WDV

« SONYA RAPOPORT: "20TH CENTURY PORTRAIT", OCT. 9 - NOV. 19, 1982 AT +LOCUS+ 5208 SANTA FE AV, L.A. 90058 »

Plate 12
Sonya Rapoport
A 20th Century Portrait (from *Objects on My Dresser, Phase 6*), Locus, Los Angeles, 1982

Web plot of Rapoport's profile.

MOTHER-DAUGHTER NETWEB OF IMAGE-WORD RELATIONSHIPS

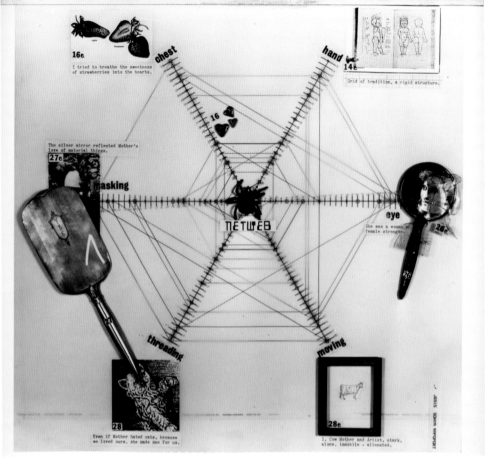

Plate 13
Sonya Rapoport
Project for Heresies *Magazine* (from *Objects on My Dresser, Phase 8)*, 1983

In a NETWEB plot, Rapoport isolates the objects that were pertinent to her mother's impact on her.

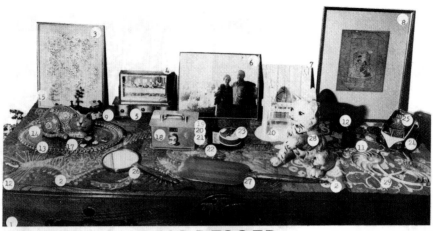

OBJECTS ON MY DRESSER

SONYA RAPOPORT

Grid of tradition, a rigid structure.

OBJECTS ON MY DRESSER
& assigned words

1 Tansu / *Holder*
2a Batik / *Sea*
2b Batik / *Love*
3 Genn Drawing / *Snakey*
4 Last Supper Dresser / *Spiritual*
5 Wood Slice / *Chip*
6 Hava & Elias Photo / *Love*
7 Nevelson Relief / *Grow*
8 Indian Drawing / *Love*
9 Crystal Knobs / *See Thru*
10 Thread Wheel / *Holder*
11 Tack Box / *Holder*
12 Cymbals / *Love*
13 Oval Glass Tray / *See Thru*
14 Cat Bank / *Child*
15 Plastic Foliage / *Grow*
16 Ceramic Hearts / *Love*
17 Screw / *Screwed*
18 Steel Bank / *Holder*
19 Pennies / *Money*
20 Envelope Change Purse / *Holder*
21 Silver Dollars / *Silver Money*
22 Satin Pocket / *Pocket*
23 Typewriter Ribbon Can / *Snow Love*
24 Toy Auto / *Car*
25 Furniture Cups / *See Thru*
26 Mirror / *See*
27 Silver Mirror / *Silver See*
28 Mother's Ceramic Cat / *Mother*
29 Shell Slices / *Sea*

IMAGES CORRELATED TO THE OBJECTS
& assigned words

1C Victorian Dresser / *Elegance*
2C Sea Object Sculpture / *Prickly*
3C Turtle / *Crawly*
4C Sea Snakes / *Slithery*
5C Doll's Eye / *Seeing*
6C El Greco "Gentleman" / *Passion*
7C Trees / *Growing*
8C Love ar First Bite / *Sex*
9C Chess Game / *Game*
10C Ferris Wheel / *Game*
11C Antique Iranian Ink Well / *Exquisite*
12C Strip Teaser's Bosom / *Sex*
13C Photo of Countess Holding Frame / *See Thru*
14C Proportions by Durer / *Child*
15C Growing Flower / *Grow*
16C Strawberries / *Luscious*
17C Drawing by Judith Bernstein / *Sex*
18C Casket / *Death*
19C Painting of Circles / *Discs*
20C Man's Slipper / *Slip-Her*
21C Bill–Joke Postcard / *Money-Joke*
22C Photo of Judith Bernstein / *Sexy*
23C Chippendale Furniture / *Elegance*
24C Kienholz' Dodge '38 / *Sex*
25C Labor-Ynth at Chartres / *Labor-Ynth*
26C Drawing by John Graham / *Spiritual*
27C Mask Sculpture / *Mask*
28C Cow on Grid Drawing / *Mother-Ambivalence*
29C Ear / *Hear*

chest hand
masking eye
threading moving

In analyzing the objects that had accumulated on my dresser I was searching for behavior patterns as documentation that reflected the culture in which I live. The objects were given numbers for identitiy and use as data in computer programs that described their shape, color, material, value and source.

I proceeded to understand the motivation for my keeping the objects when I made a correlated set of images that related to the objects. Words were then assigned to each set. In discussions with psychiatric social worker Winifred De Vos, a netweb of underlying meanings emerged from the image to image and image to word associations.

The set of objects and the set of related images became one set of object-images in the future phases of the work. Themes reoccurring in the dialogues established the words for the six axes of the web structure upon which the images can be placed.

Sonya Rappaport lives in Berkeley, CA. Her interdisciplinary work documents behavior in participation performances using biographical sources. She has performed in New York at Franklin Furnace the Clocktower, Sarah Lawrence College, and Artists' Space.

Plate 14
Sonya Rapoport
Project for Heresies *Magazine* (from *Objects on My Dresser, Phase 8)*,1983

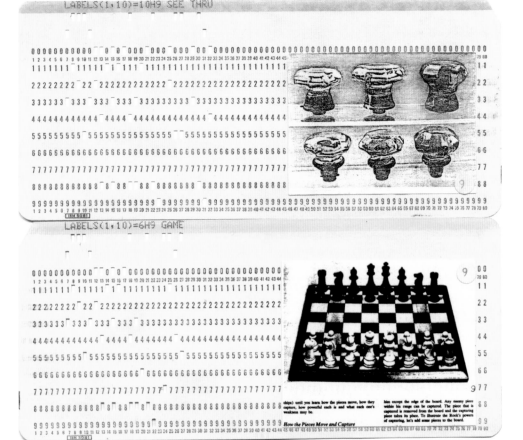

Plate 15
Sonya Rapoport
Objects on My Dresser, Phase 3, 1980

Punch cards of object (glass knobs) and of its correlated object (chess game). This data was used for computing the NETWEB plot.

Plate 16
Sonya Rapoport
Back to Nature (from *Objects on My Dresser, Phase 7*), Humboldt State University, Arcata, California, 1983

Objects on My Dresser are conceptually recycled into landscape photographs by James Randklev.

15" H x 253" W

Plate 17
Sonya Rapoport
Surface, Isomorphic Series (from *Objects on My Dresser, Phase 11.1*), 1981
(Portrait originally by Adolphe Braun, Countess Castiglione, c. 1860)
11" H x 132" W

Detail of enlarged computer forms of chemistry models visually related to the objects. Color image on acetate is superimposed. Mounted on rag paper.

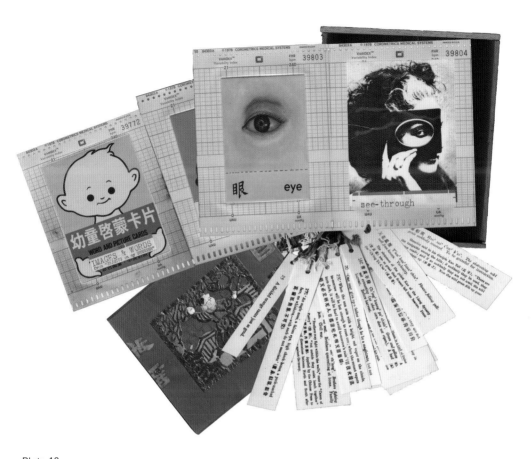

Plate 18
Sonya Rapoport
Chinese Connections (from *Objects on My Dresser, Phase 9*), 1982
Chinese Word/Picture cards, laminate, yarn, Chinese proverbs, business computer forms

Chinese Word/Picture cards correlated with images of the objects that are combined to be assimilated into a verbal proverb.

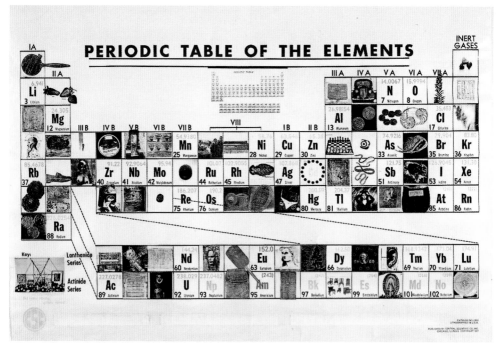

Plate 19
Sonya Rapoport
Periodic Table of the Elements (from *Objects on My Dresser, Phase 10*), 1979
41½" H x 56" W

Each element square has a collaged image of an object that begins with the same letter.

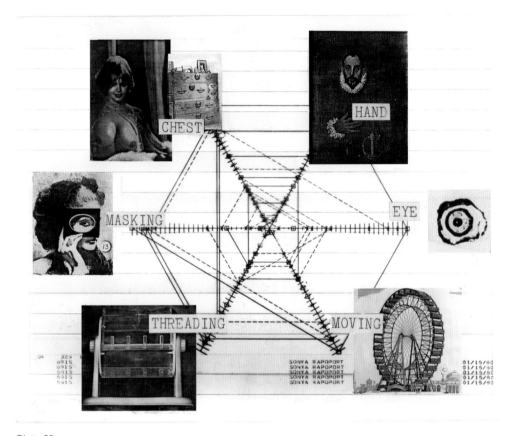

Plate 20
Sonya Rapoport
Exhibition in Print (from *Objects on My Dresser, Phase 4)*, LAICA, 1981
Printed by Calcomp plotter on vellum, collage, postcards from Prado, eye from glass doll, Ferris wheel, threading wheel spool holder, photo by Adolphe Braun, stripper postcards
Size variable (digital print)

Readers participate by correspondence.

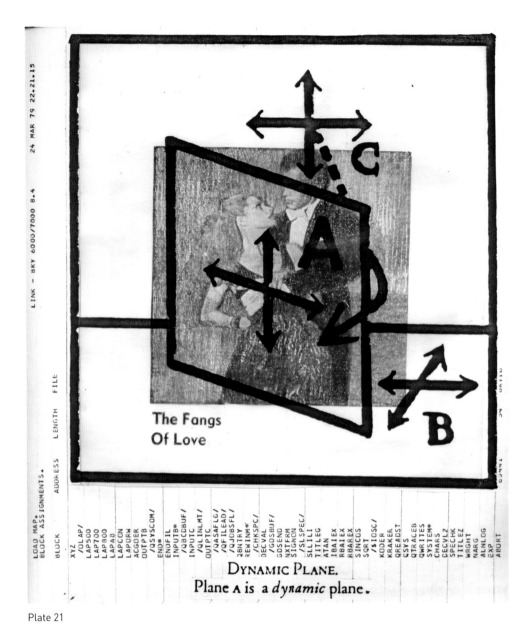

Plate 21
Sonya Rapoport
Chelate: Fangs of Love/Dynamic Plane, Isomorphic Series (from *Objects on My Dresser, Phase 11.2*), 1981
Diagram from Erle Loran's book *Cézanne's Composition* printed on enlarged computer forms containing research on the chelating process. Color image on acetate is superimposed. Mounted on rag paper.
20" H x 176" W

DIAGRAM III

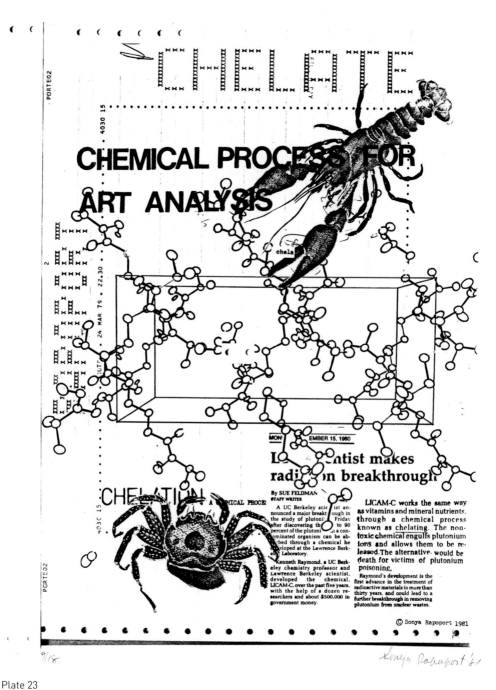

Plate 23
Sonya Rapoport
Chelate: Chemical Process for Art Analysis, Isomorphic Series (from *Objects on My Dresser, Phase 11.2a*), 1981
Detail of 15" H x 176" W

A chemistry structure related to the art formalism of the objects.

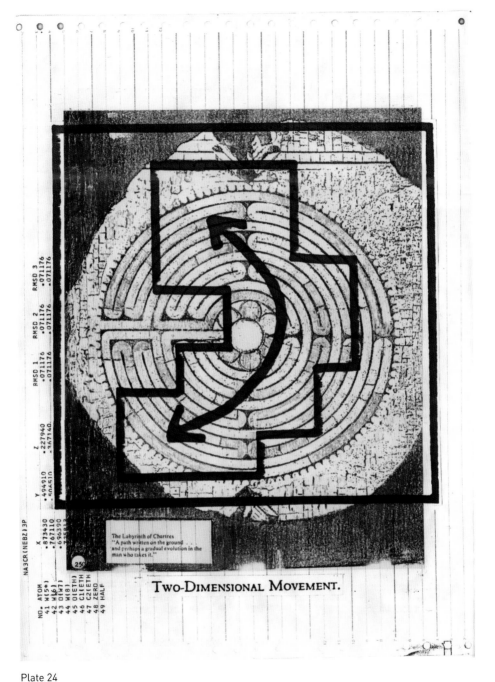

Plate 24
Sonya Rapoport
Chelate: The Labyrinth of Chartres/Two-Dimensional Movement, Isomorphic Series (from *Objects on My Dresser, Phase 11.2b*), 1981
Diagram from Erle Loran's book *Cézanne's Composition* printed on computer form containing research on the chelating process, color image printed on acetate. Mounted on rag paper.
Detail of 15" H x 176" W

WHY I WEAR THESE SHOES?

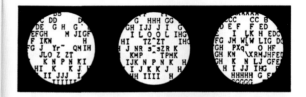

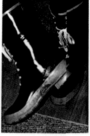 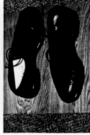

50. Fulfilling a fantasy be-
ing a Northwoodsman, romping
around in the rain & the mud.

49. ...to use as character re-
ference, trying to create a
very severe business quality.

48. I feel more macho...point-
ed toes to get into the stir-
ups, it's insertion, masculine.

Plate 25
Sonya Rapoport
Why I Wear These Shoes? (supporting document from *ShoeField*), 1982
Illustration from *BOX CAR* magazine
11" H x 15" W

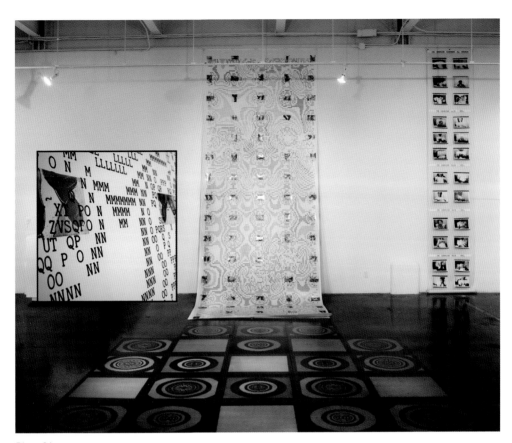

Plate 26
Sonya Rapoport
ShoeField (includes *ShoeField Print Map* and *33 ShoeField Tiles*), 1982–88
Mixed media
Size variable

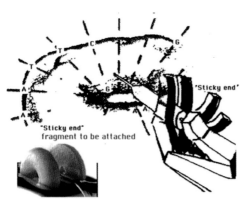

Bagel Fragment DNA

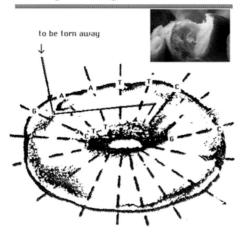

Bagel Cleavage Site

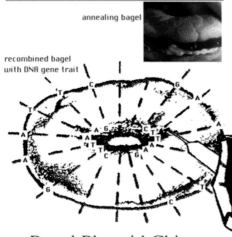

Bagel Plasmid Chimera

Plate 27
Sonya Rapoport
The Transgenic Bagel, 1993–96
Website
Size variable

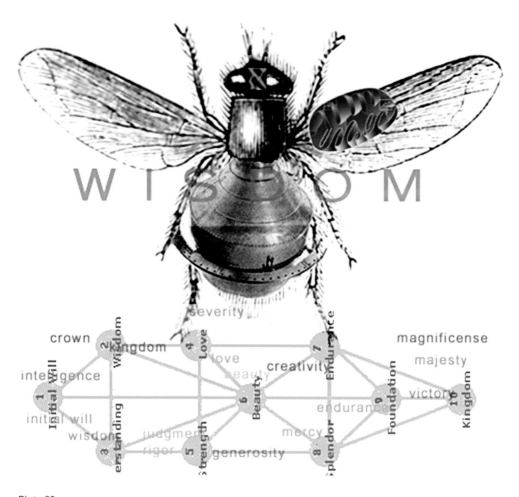

Plate 28
Sonya Rapoport
Kabbalah Kabul: Sending Emanations to the Aliens, 2004
Website
Size variable

smell your destiny

trait pill

⇩

⇨ CH_3NH_2

by sonya rapoport

designing
the brain
for
success

sniff a trait
for your fate

past modes
of behavior
are not
rewarded
today

smell now

PLATE 29
Sonya Rapoport
Smell Your Destiny (detail of homepage), 1995
Website
Size variable

Introduction

Pairings of Polarities: Sonya Rapoport's Art and Life

Terri Cohn

> A key to my work is the synapse of two unlikely entities, a dissi-
> dent or serendipitous pair triggered into dialogue. Chaos emerges
> from the convolution of these polar entities until a meaningful
> resonance is resolved.[1] —*Sonya Rapoport*

"Pairings of Polarities" is a multifaceted metaphor for Sonya Rapoport's life and
work. An idea that can be interpreted on one level as scientific, it also describes the
dynamic ways Rapoport brings together and forms alliances between ideas, themes,
objects, and events from distinct parts of her life and the world. Since the beginning
of her post-painterly career in the early 1970s, her Conceptual artwork has reflected
an inherent interdisciplinarity. Relationships between people, places, and things—
queens and rock stars, blowflies and outer space, domestic objects and mudras—are
held in intricately linked sets of verbal, visual, and associative systems, and these
reveal the breadth of Rapoport's artistic interests and the latitude of her worldview.[2]

One of the significant themes of this book is the ways that Sonya Rapaport's
experiences, told in myriad stories, have inspired her art. This is not unique: artists of
all disciplines have interwoven personal and public concerns in their art throughout
the centuries. Rapoport's paths of exploration, however, have been unusual, ongoing,
and layered, and her discoveries in wildly different arenas. She consistently inter-
weaves diverse ideas—concepts from science, technology, feminism, gender, religion,
anthropology, botany, popular culture, and world events—with the domestic and the

1

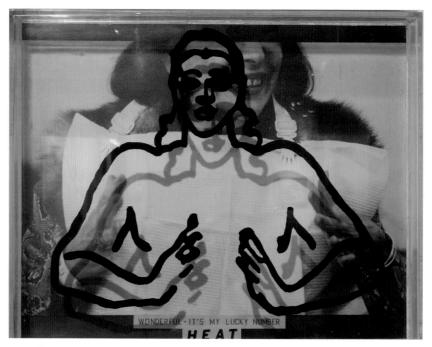

Sonya Rapoport
Biorhythm: The Computer Says I Feel, 1983
Photographs and text overlaid with drawing on plexiglass, 8" H x 10" W

personal, creating new paths to holistic meanings. Attracted to the liaisons between seemingly unlike entities, Rapoport has spent forty years devising creative modalities that link and hold disparate—even contradictory—elements. Information, knowledge, fact, and fiction coexist in her systems, at some points intersecting and, at others, moving in parallel with each other. The connective tissue is her creative vision, that galaxy we loosely refer to as "art."

Artistic Genesis

Rapoport's early years as a graduate student in the University of California, Berkeley, art department, and in particular her formalist training as a painter, shed light on her later work in media that by their nature are "more open-ended and indeterminate."[3] Key to Rapoport's aesthetic were the UC Berkeley art department's curricular focus on "formal structure" and the required text *Cézanne's Composition: Analysis of His Form with Diagrams and Photographs of His Motifs,* which Erle Loran used in his course on Cézanne's compositional techniques. While Rapoport's early work as an Abstract

Expressionist painter reflected the prevailing aesthetic of the late 1940s and 1950s, the visual "grammar" Cézanne used to paint what he saw influenced her future styles. In Rapoport's work, psychological depth is grounded in rigorous formal structures, and a piece functions "less as a painted picture than as a diagram of ideas."[4] The idea to embed content in structure was heavily influenced by Loran's diagrammatic approach to explicating the picture plane. As Rapoport discussed in an oral history with Richard Cándida Smith, she analogously employed Loran's approach in her key multiphase work *Objects on My Dresser* (1979–83), to "show how the movement in a painting circulates and doesn't get lost in perspective."[5] (See Plate 21 and Plate 22.)

Although initiated into "the Berkeley School" (influenced by Hans Hofmann's doctrine of the tension between shapes within compositional space), Rapoport soon began to embed scraps of painted canvas into her large-scale, heavily impastoed canvases. By 1963, after a midcareer exhibition at the California Palace of the Legion of Honor in San Francisco, she began to explore the ways in which her Abstract Expressionist explorations could merge with "scientific diagrams, organic shapes, and budding feminist themes in [her] media medley of paint, graphite, and collage."[6]

During this early period, Rapoport was also busy raising three young children and became excited by the scientific imagery, data, and methodologies she found in her husband's chemistry journals. This unlikely pairing of domestic activity and analytical interests prompted a period of foraging for shapes that were "emotionally explosive icons."[7] She collected such small images and shapes as canned fruit labels, wallpaper designs, toy anatomy templates, a bridge from a billiard set, a uterus shape, and a fallen leaf and stored them in her *Pandora's Box* (1962–72), creating her first repository of symbols (see Plate 1). She dubbed this collection of personal icons her "Nu Shu alphabet"—a reference to an ancient, secret script invented and used sub rosa by Hunan Chinese women. Accordingly, Rapoport entered the world of Conceptual art practice—in an actively formative stage during the mid-1960s—and the interrelated arenas of feminist discourse and art forms that were also emerging during that time.

Survey Charts and Computer Printouts

In 1970, Rapoport unlocked an antique architect's desk she had purchased a decade earlier. Inside, she discovered a series of geological survey maps from 1905, which reinforced her attraction to scientific data and geometric forms. She began to draw on top of these prints, incorporating the Nu Shu language shapes, interested in the ways in which the maps' coded information interfaced with references to birth and gender inherent in the *Pandora's Box* motifs. The methodology she devised through this process further directed her pivotal transition to conceptually based art practice.

During this formative period of Rapoport's early post-painterly era, the importance of family life, especially around the dinner table, was key to the evolution of her work. As she described it to me early on in our conversations about art, life, and especially her own work, "this was the beginning of it all."[8] While she was raising

her family during the mid-1960s to mid-1970s, her husband, Henry Rapoport, was a professor of chemistry at UC Berkeley, and their dinnertime conversations revolved, in part, around the intellectual world of the university. Rapoport herself would often wander the halls of the mathematics building, where a huge, room-sized computer and Calcomp printer were located. There, she discovered the computer printouts that became a foundation for her own drawings, as well as the impetus for her creative riffs on the printouts' content. As Rapoport describes it:

> In the hallway were the recycling bins where the printouts
> were discarded to be recycled. At first I timidly helped myself
> to anything…(but) as time went on I developed a discerning eye
> for which printed patterns the experiments created and which
> size and line color would serve my aesthetic purpose.…Later, I
> worked independently with this equipment to create my web
> plots and various diagrams.[9]

Rapoport was on a quest to determine her next arena of artistic exploration, and the discourse and materials offered by academia, as well as her relationships with its practitioners—some of whom, like anthropologist Dorothy Washburn, became her collaborators—were fundamental to the form, content, and direction of Rapoport's work.

Hava Rapoport, Sonya's daughter, talks about the "ready access to images" that her father's field of work offered and how much he enjoyed sharing this with his family. However, as Hava also points out, Sonya reached beyond the realm of her husband's interests in her interdisciplinary approach to working with scientific ideas. For example, she was also attracted to her daughter's work with plant growth and development, as well as reproductive biology—especially relative to the sugar beet, alfalfa, and the olive tree—which influenced her explorations of related imagery and iconography.[10]

Hava acknowledges how her mother's humorous and intelligent play with scientific themes opened her eyes to "how science and scientific pursuit appear to non-scientists and encouraged me to examine and define my own views on these issues."[11] The community created by the natural exchange and sharing of knowledge among Rapoport's highly educated nuclear family soon served as her own built-in research group, which she has continued to expand to include a network of individuals from multiple scientific, technological, artistic, academic, and socially engaged fields.

Rapoport's mutually influential relationship with Washburn, who studied Anasazi Indian pottery designs and taught in the anthropology department at UC Berkeley during the early 1970s, was particularly consequential. Driven to find out how certain computer printouts were encoded, Rapoport began working with Washburn, who taught her how to decipher them and how to decode them. While the collaboration between Rapoport and Washburn was of particular significance to Rapoport's process of adapting the systematized language of computer printouts, it came to be equally important for Washburn. As she wrote of their alliance:

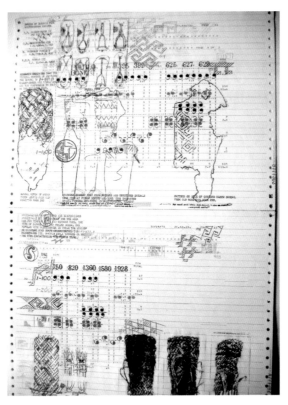

Sonya Rapoport
Shoes, Sandals, Codes (detail/*Bonito Rapoport Shoes*), 1978
Computer printout, graphite, typewritten text, 110" H x 15" W

> It has shown me that the act of combining parts to make a
> whole lies at the heart of the creative process and therefore that
> codifying this process in symmetry classes [what her research
> accomplishes] is a valid, meaningful classificatory procedure.
> Basic aspects of arrangement of forms in space and colors with
> forms, for example, appear to be handled in similar ways whether
> it be an ancestor statue carved by a primitive artist in 2000 BC
> or a large canvas by an abstract expressionist in AD 1978 [12]

As another outcome of her collaboration with Washburn, Rapoport also discovered "how indeterminate content reflecting her interests and those of her viewers could provide formal structural principles governing this new work."[13] This discovery encouraged her incorporation of not only cultural and scientific data, but also an element of chance in her work, which fully emerged in the form of interactive

installations during the late 1970s and 1980s, among them *ShoeField* (see Plate 25 and Plate 26), *Digital Mudra* (see *Biorhythm* above), and *Objects on My Dresser* (see Plates 7 to 24).

Cándida Smith characterizes Rapoport's work as an ongoing reshuffling of "inputs," which could be "feelings and responses, if that is what the artist chose, or they could be objects, forms, or images. Or the inputs could be audience-generated responses, which even if they fell into regular patterns were by definition unknown and unpredictable at the outset. Any of the input sets could be organized into a coherent visual pattern, if she chose to do so, since chance is probabilistic rather than random."[14] Chance is a salient feature of Rapoport's work and relates strongly to her tendencies as a Systems Conceptual artist and her inclination to relate the formal-mathematical and social realms.

Systems Conceptual Art

By developing her own visual language system within a scientific format, Sonya Rapoport fuses traditional concerns of the artist with contemporary involvement with information and language structure, producing a synthesis of aesthetics and technology which I believe presents us with a clear glimpse of the future. — *Stephen Moore, Director, Union Gallery*[15]

Sonya Rapoport
Genesis (detail from the *Explicit Transcription* series), 1975–76
Graphite and color pencil applied with stencils on "found" white-and-gray-barred computer forms, 15" H x 52" W

Sonya Rapoport
Arbor Erecta: A Botanical Concept of
Masculinity, Web artwork, 1998
Photos of trees courtesy of Emily Goldberg

Rapoport's high regard for scientific inquiry has infused her work throughout her career, though she "recogniz[ed] that the power of these standard forms was produced by their place in a system, a larger structure of beliefs. She embarked on a long series of works manipulating symbolic systems through associations, juxtapositions, and displacements of imagery, revealing the workings of the systems and uncovering hidden patterns of thought."[16] The relationship between scientific data, models, and methodologies, evident from early in her career, was inspired in part by the images and diagrams that she found in her husband's scientific journals—first for graphical ideas and later by their content.[17]

While Rapoport was developing her work with written and visual language systems grounded in scientific format in the early 1970s, Conceptual art was emerging around the world. Though her interests were primarily in the areas of language and actions—the most widespread approaches to Conceptual art—she was also deeply involved with systems, a far more abstract approach. Rapoport's attraction to systems naturally emerged from the scientific milieu of her family life, as well as her early method of superimposing diverse types of information in the process of creating discrete works of art. A key example from this period is her *Explicit Transcription* series (1976–79), in which she incorporates text from newspaper articles, stencils from the *Pandora's Box*, and color-coded letters traced from an alphabet template and drawn directly on computer printouts. The accompanying legend features tiny squares filled with color; each color corresponds to a word that identifies a passage in the Old Testament. This was Rapoport's first attempt to create an "explicit translation" of text, and because it allies and associates different types of text, it is also an example of language-based Conceptual art.

Rapoport has often created parallel systems of representation, naturally linking her process-based intellectual concerns, performance-based art, and the formal/

mathematical and social realms. Numerous Conceptual artists who also emerged during the early 1970s—among them Martha Rosler, Hanne Darboven, Mel Bochner, Joseph Kosuth, On Kawara, Sol LeWitt, and Adrian Piper—likewise had serialized approaches to art making, creating their own complex numerical and/or linguistic systems. Although the works of these artists have similarities and differences, their use of sequential systems—generally with a preset plan for realizing their aesthetic ends—has been described as "allow[ing] the work of art, in effect, to create itself while remaining grounded in the reality of external factors of existing facets of representation."[18] Based on the creation of complex numerical and/or linguistic systems, Hanne Darboven's art-making process features her daily "writings," which chronicle existence and evoke the passage of time. Darboven marked duration in a literal form, which also gains dimension when the writings are installed in a gallery space. Her systematic approach included devices like numerical codes, words, and photographs, all present in her key work *Leben, leben/Life, living* (1997–98), comprising 2,782 typed and handwritten daily writings or drawings that schematize the time between 1900 and 1999. The drawings make visible two orders of time: the actual time taken to create them and the historical time that they summarize.[19]

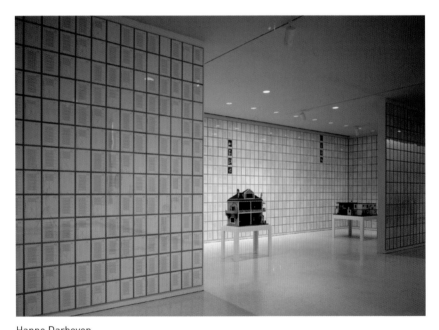

Hanne Darboven
Leben, leben/Life, living (detail), 1997–98
2,782 works on paper, 11 13/16 x 7 7/8 inches (30 x 20 cm) each; 32 photographs,
11 13/16 x 7 7/8 inches (30 x 20 cm) each; 2 dollhouses; installation dimensions variable
(installation view). *Carnegie International* 1999/2000. Image courtesy Carnegie Museum
of Art, Pittsburgh. © 2011 Artists Rights Society (ARS), New York / VG Bild-Kunst, Bonn.

Like Darboven, Rapoport understood that by anchoring her works in time, she escaped the constraints of a two-dimensional grid. Rapoport describes how her *Charlie Simonds: Microcosm/Macrocosm* (1976; see Plate 3)—with its stenciled shapes on "found" white-and-gray-barred computer printouts— "reconnected me with the golem still embedded in the earth and the survey maps' earth and water profiles."[20] In this way, Darboven's and Rapoport's systematic processes give structure and form to their work but also allow for deeper meaning and a sense of historical continuity.

Interactive and Systems Conceptual Artworks

One of the progenitors of the interactive, process-based art that emerged during the 1970s was Hans Haacke, whose systems harnessed and consumed physical energy and involved the viewer as an engaged element of the work of art. Referred to as "real-time" forms of art, such practices were inspired in part by advances in the field of cybernetics, the study of closed, self-adapting (via feedback) systems. Haacke and many other pioneering artists of the 1960s and 1970s working with performance, video, and other time-based media believed that these new media would usher in a social utopia extending beyond the realm of the experimental art world. For these artists:

> The feedback loops, live circuits and video flows, coupled with the electronic image's immediate and physiological stimula-tions…posited potent possibilities for cybernetic consciousness, ecological human-machine systems, and an end to top-down power relations. In short, the rise of an egalitarian, democratic society through electronic media.[21]

In Haacke's approach, predicated on models of social engagement, the viewer of an artwork participated in its production. In 1970, as part of the exhibition *Information* (held at the Museum of Modern Art, New York), Haacke's *MoMA-Poll* invited visitors to cast ballots in response to the question, "Would the fact that Governor Rockefeller has not denounced President Nixon's Indochina Policy be a reason for you not to vote for him in November?"[22] At the end of the twelve-week exhibition, the contents of the ballot boxes were tallied, yielding 68.7 percent "yes" votes and 31.3 percent "no." By specifying Rockefeller, who was running for reelection as governor of New York and considering entering the presidential race, Haacke implicated Rockefeller's famous family, which had a major impact on New York's cultural life, including the Museum of Modern Art. Haacke pursued similarly inflammatory, audience-engaged institutional critiques at numerous other museums during this time; predictably, he was censored from collections and exhibitions at US museums for a dozen years.

Although different in intention, the methodology Haacke used for his *MoMA-Poll* is similar to that used by Rapoport for her interactive installations. These were a focal point of her work during the 1980s, among them the multipart installations *Objects on My Dresser* (1979–83), *ShoeField* (1982–88), and *Digital Mudra* (1987).

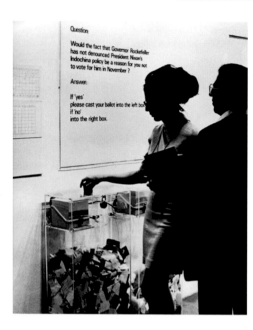

Question:

Would the fact that Governor Rockefeller has not denounced President Nixon's Indochina policy be a reason for you not to vote for him in November?

Answer:

If 'yes' please cast your ballot into the left box; if 'no' into the right box.

Hans Haacke
MoMA-Poll, 1970
Ballot box, mixed media

This work was included in the Information exhibition, MoMA, 1970. ©Hans Haacke/ARS. Courtesy Paula Cooper Gallery, New York

ShoeField is a particularly important example of Rapoport's Systems Conceptual art: she considers it her "first audience participation performance."[23] Participants in the various incarnations of *ShoeField* were given a number upon entry into the gallery. During the event, a second number—or a charge value (-2 to +2)—was calculated from their answers to a questionnaire given on a computer in the gallery, which asked how they felt about their shoes.[24] Rapoport further interwove the formal/mathematical and social realms by generating a "force field map," computed in an electric field theory program using various pieces of data gathered from participants. Each of the seventy-six original installation participants is each identified by a tilde on the map, positioned according to his or her gallery entry number. Letters and other characters selected by the computer program surround the tildes; their proximity to the tildes relate to participants' answers to the preliminary shoe survey (see Plate 25 and Plate 26).

This piece builds on Rapoport's earlier work with computer printouts in her collaboration with Dorothy Washburn. Equally important is how Rapoport "work[ed] out a structure of human relations" in *ShoeField*, even though it is based on people's relationships with inanimate objects.[25] In the context of some of Rapoport's fundamental theories about her art—which include "quantifying qualitative information" and "ontology recapitulates phylogeny"—*ShoeField* is a key work. It marks her transition from corporeal notation to computer-generated forms of representation and interaction, while preserving her deep desire to engage others collaboratively to create and complete her work.

Interactive Art Making: *Objects on My Dresser*

Rapoport's entrée into the world of interactive art making was her multiphase work *Objects on My Dresser*. Begun in 1979, this piece grew out of earlier works that were focused on other cultures and artifacts. With a desire to systematize and archive the random set of objects that had accumulated on her dresser over an approximately twenty-year period, Rapoport first conceived a psychological analysis of the objects that utilized image-to-image and image-to-word associations. Her reevaluation of a personal, random set of objects through the lens of a technological system is another example of Rapoport's quantification of qualitative information; she also discovered things about her own behavior patterns. As part of this process, she engaged a psychiatric social worker, Winifred De Vos, to document "aesthetic and emotional responses about the objects and my connective associations."[26] Rapoport acknowledges the deep influence of this work on the viewer-interactive pieces she created in later phases of her career.

Rapoport's central interest with this eleven-phase piece was to work with a set of objects that had personal meaning to her. She compiled a complementary set of objects with the intention of visually expressing something psychologically meaningful about herself through associative relationships between the two groups. Objects from both sets were given numbers for identification and used in computer programs that described their shape, color, material, value, and source. Each object was also assigned a word. Via discussions with De Vos, a "NETWEB" of underlying meanings emerged from the image-to-image and image-to-word associations (see Plate 9).

Each phase of *Objects on My Dresser* was independently conceived, but themes were carried through subsequent phases, revealing aspects of Rapoport's life during the five years she was immersed in the project. For example, in an early phase of the project *Psycho-Aesthetic Dynamics* (1980), Rapoport set up an empty plot with themed axes on a gallery floor. She distributed cards carrying xeroxed images and invited participants to fill the empty plot, making their intuitive correlations between the images on the cards (see Plate 9). *Shared Dynamics* (1981), *Phase 3* of *Objects on My Dresser*, compares the associative webs produced by artists, scientists, and lawyers. Rapoport went beyond the confines of the gallery space in *Phase 5, The Object Connection* (1982; see Plate 10), when she involved passersby on the street and readers of *Heresies* magazine, which published her data about the correlative tendencies of different participants and solicited readers' own (*Project for* Heresies *Magazine, Phase 8*, 1983 (see Plate 13 and Plate 14). For this phase Rapoport isolated the objects that signified her mother's impact on her, and juxtaposed them with their assigned words and correlated images. This phase also includes an image of the NETWEB, surrounded by keywords—chest, hand, moving, threading, masking—that represent recurring themes in the evolving piece.[27]

Consistent with her other interactive installations, Rapoport plays with basic concepts of semiotics—signs and signifiers, intention and message—in ways that are both publicly accessible and connotatively covert in *Objects on My Dresser*. Several of Rapoport's contemporaries used similar strategies—in particular, Martha Rosler,

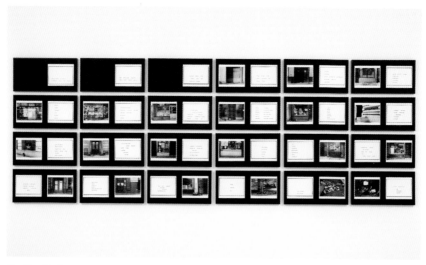

Martha Rosler
The Bowery in Two Inadequate Descriptive Systems, 1974–75
Series of 45 gelatin silver prints of text and images on 24 backing boards, each backing
board 11 $^{13}/_{16}$ × 23 $^{5}/_{8}$ inches (30 × 60 cm)
Courtesy of the artist

whose work, like Rapoport's, confronts issues ranging from gender stereotyping and advertising to war and the media. Analogous to *Objects on My Dresser*, Rosler's *The Bowery in Two Inadequate Descriptive Systems* (1974–75) juxtaposes words and images. However, while Rosler concentrates on the evidence of absence (empty liquor bottles, assorted street detritus that mark the passage of time, and humans—the usual subject of Bowery photographs), Rapoport focuses on the creation of meaning (the public is invited to rearrange words, images, and components in personally significant ways) in certain phases of *Objects on My Dresser*.[28]

Generational Considerations: Looking Back, Looking Forward

Objects on My Dresser is a key work in the context of Rapoport's career. The multi-phase, system-based work quantifies qualitative information and is realized in part by audience interaction. Moreover, Rapoport's concept of the NETWEB, the spiderweb-like diagram that illustrates associations generated by the objects on her dresser, was first realized materially in *Objects on My Dresser* (see Plate 9). When the World Wide Web became available for individual use in the mid-1990s, Rapoport recognized the methodology she had worked with fifteen years earlier, and it seemed natural for her to create interactive computer-assisted artworks that continued her work within this paradigm. For Rapoport, the web represents the connections—between images,

objects, and language—which form the "building blocks of our relationships, [and are] linked by webs of information spun by the mother."[29]

When Rapoport began making webworks in the mid-1990s, she was drawn to themes that had long interested her, in particular scientific and gender issues. Among her projects, *Brutal Myths* (1996), a collaboration with Oakland artist Marie-José Sat, explores social conventions that have historically oppressed women. Inspired by the medieval witch-hunting manual *Malleus Maleficarum (The Witch Hammer)*, it leads participants on an interactive process of discovering ancient herbal cures to erase abusive female mythologies. The sense of hopefulness present in *Brutal Myths*, which is a significant counterpoint to the work's implied cruelty, is amplified in *Kabbalah/Kabul: Sending Emanations to the Aliens* (2004), in which Rapoport concludes that embryonic stem cells ultimately transmit emanations of altruism and can counter the destructive nature of war.[30] (See Plate 28.) When a participant selects an emanation (by clicking on its icon), an associated image of a stem cell within a cell cluster differentiates and lights up, changing into a body part. The selected cell's DNA is then enhanced with an altruistic genetic trait in preparation for delivery to the extraterrestrials. *Kabbalah/Kabul* attempts to integrate the physical outer universe with the altruistic, inner personal "universe." The consistently contradictory messages in these works—also evident in Rapoport's biblically referential and parodic *Smell Your Destiny* (1995; see Plate 29) and *The Animated Soul: Gateway to Your Ka* (1991; see Hava Rapoport chapter)—illustrate her ongoing interest in how the scientific and the mystical, as well as the political and the personal, can naturally be paired. This attitude remains an essential model for younger artists, many of whom, despite the fraught nature of contemporary life, continue to pragmatically and poetically envision possibilities for the future.[31]

The resonance of Rapoport's work is reflected in the perceptive statement she made to introduce her 2003 alumni talk at UC Berkeley:[32]

Sonya Rapoport,
Brutal Kicks, Michael Jackson, 1996/2009

Rapoport has updated an image from
her *Brutal Myths* series based on
Jackson's life and death.
Digital image, size variable

> Having survived Art 2A, I eventually landed in Cyberspace.
> I have been asked "why" many times; and every time I give a
> different answer. I don't really know "why."...I contend that my
> use of digital media and computers is of a continuum of the old
> 2A rather than a departure to "another idea of art."

It is essential to recognize that Rapoport's shift from creating autonomous objects to interactive installation work in real time and space was a consequence of her immersion in the zeitgeist of the 1970s. Her continued exploration of the world of digital media as "a continuum of the old 2A" underscores Rapoport's belief that her lifelong artistic process of creating systems that link seemingly unlike ideas, themes, objects, and events is a continuum of intellectual and artistic exploration, one which has led her from Abstract Expressionist painting to interactive webworks. Her unique attraction to pairing polarities is central to her remarkable, decades-long artistic exploration and achievement.

Notes

1. From Meredith Tromble's chapter in this volume.

2. Examples of Rapoport's visual, verbal, and associative systems are evident in her Artblog, http://sonyarapartblog.blogspot.com/.

3. In his chapter in this volume, Richard Cándida Smith discusses, in depth, ideas about how Rapoport's new media and performance work grew out of the focus on formal structure in her graduate studies in art at UC Berkeley during the late 1940s and early 1950s.

4. Cándida Smith chapter, footnote 5.

5. In her interview with Cándida Smith, Rapoport continues by explaining that "This diagram is superimposed upon the picture of objects on my dresser...[and] how the Berkeley system is evolving into applying something conceptually, and using a narrative." (See p. 27.) This was key to the future development of her conceptual but narrative approach to art making.

6. Sonya Rapoport, "Digitizing the Golem: From Earth to Outer Space," *Leonardo* 39, no. 2 (2006), 117. As Rapoport notes in this essay, in her "Combine" paintings, done between 1964 and 1967, several canvases with different imagery were adhered to one structure.

7. Ibid.

8. In her chapter in this volume, Hava Rapoport restates the importance of the family table to the evolution of her mother's work as an artist.

9. Email from SR to TC, January 27, 2011.

10. Related images include *Make Me a Jewish Man* (included in Hava Rapoport's chapter, p. 20). Thematically, *Make Me a Jewish Man* interweaves "the morphology of the olive tree with the Talmudic concept of the Ideal Man" (see Sonya Rapoport website, www.sonyarapoport.net, for more).

11. Hava Rapoport chapter. It is also significant to learn that the source of some materials and themes came from Hava's own doctoral work at UC Davis as part of the agronomy department research group SUBGOL sugar beet model, or from her vegetable crops department colleague James Bennett.

12. Dorothy Washburn, *Interaction: Art and Science*, Truman Gallery, New York City, Jan. 12–Feb. 3, 1979, as noted in John Zarobell's chapter, pp. 59–60.

13. Cándida Smith chapter, p. 30.

14. Ibid., p. 32.

15. Stephen Moore, "Introduction," *Sonya Rapoport: An Aesthetic Response*" (exhibition brochure), Union Gallery, San Jose State University (October 9–November 3, 1978).

16. Tromble chapter, page 65.

17. For example, she interwove scientific and mystical themes in *Arbor Erecta: A Botanical Concept of Masculinity*, 1998, which focuses on New Guinea tribal initiation rituals that purge the "female pollutants" from the male body (acquired from the mother). The project brings together themes of political incorrectness and gender disparity, along with enough ironic humor to make them palatable.

18. Anne Rorimer, "Approaches to Seriality: Sol LeWitt and His Contemporaries," from *Sol LeWitt: A Retrospective* (San Francisco: SFMOMA, 2000), p. 63.

19. Darboven's *Leben, leben/Life, living* also includes two dollhouses that are part of her extensive collection of popular artifacts. The houses—photos of which are included in the installation— also mark time, as one represents a nineteenth-century German home and the other a house from the 1950s. Darboven's work is reminiscent of Rapoport's *Doors of My House* (1978), an example of her early process art that is based on systems mapping. It utilizes database computer programs with the intent of illustrating the aesthetic quality of computer plots and their kinship to art. *Doors of My House* started with the intent to create a work of art using a technical subject with prevailing computer technology, but became a broad statement of time and place as well as a personal one.

20. Sonya Rapoport, "Digitizing the Golem: From Earth to Outer Space." *Leonardo* 39, no. 2 (2006), 119.

21. Carolyn Kane, "The Cybernetic Pioneer of Video Art: Nam June Paik," *Rhizome.org*, May 16, 2009, http://rhizome.org/editorial/2009/may/6/the-cybernetic-pioneer-of-video-art-nam-june-paik#.

22. This quote is posted on the wall as part of Haacke's 1970 *MoMA-Poll* installation.

23. Titled *Shoe-In*, this first incarnation of *ShoeField* was held at Berkeley Computer Systems in 1982.

24. John Zarobell talks about this in his chapter, p. 63.

25. Ibid.

26. From Anna Couey and Judy Malloy's chapter, p. 40.

27. *Objects on My Dresser* is an extremely important work in the development of Rapoport's computer-assisted interactive installations, and it is extensively discussed in Couey and Malloy's conversation with Rapoport. Subsequently, I have limited my discussion of it. In regard to the significance of *Phase 8* of the work, Rapoport considers it the end of her grieving period for the loss of her mother. Meredith Tromble also discusses key aspects of this work in her chapter.

28. Rosler juxtaposes the images in this work with lists of synonyms for drunkenness or drunks, as well as such words as "dead soldiers, dead marines," thereby amplifying the void of representation while alluding to the unknowable abyss experienced by what was at one time referred to as the "Bowery bum."

29. From Anu Vikram's chapter, p. 93.

30. Rapoport presented a paper related to this work in Paris in 2003 at a SETI (Search for Extraterrestrial Intelligence) Workshop, Encoding Altruism: The Art and Science of Interstellar Message Composition.

31. Anu Vikram writes in her chapter about the model Rapoport's work set for a younger generation of women artists, who may not be directly impacted by her work, but whose vision is contingent on the personal, political, and artistic model of Rapoport's life and work.

32. The text of Rapoport's talk is available at http://www.lynnerutter.com/Artletters/Rapsymposium_1.pdf. A modified version of this quote is also part of the opening of Richard Cándida Smith's chapter.

References

DeSalvo, Donna M., and Johanna Burton, eds. *Open Systems: Rethinking Art*. London: Tate, 2005.

Frieling, Rudolf, ed. *The Art of Participation: 1950 to Now*. San Francisco: San Francisco Museum of Modern Art, 2009.

Grasskamp, Walter, Molly Nesbit, and Jon Bird. *Hans Haacke*. New York: Phaidon, 2004.

Heylighen, F., C. Joslyn, and V. Turchin, "What Are Cybernetics and Systems Science?" *Principia Cybernetica Web*, Oct. 27, 1999: http://pespmc1.vub.ac.be/CYBSWHAT.html.

Kane, Carolyn. "The Cybernetic Pioneer of Video Art: Nam June Paik." *Rhizome.org*, May 6, 2009: http://rhizome.org/editorial/2009/may/6/the-cybernetic-pioneer-of-video-art-nam-june-paik/.

Loran, Erle. *Cézanne's Composition: Analysis of His Form with Diagrams and Photographs of His Motifs*. Berkeley and Los Angeles: Univ. of California Press, 1943.

Malloy, Judy, ed. *Women, Art, and Technology*. Cambridge, Mass.: MIT Press, 2003.

Morse, Margaret. *Virtualities: Television, Media Art, and Cyberculture*. Bloomington and Indianapolis: Indiana Univ. Press, 1998.

Nakamura, Lisa. *Cybertypes: Race, Ethnicity, and Identity on the Internet*. New York and London: Routledge, 2002.

Osborne, Peter, ed. *Conceptual Art*. New York: Phaidon, 2002.

Rapoport, Sonya. "Digitizing the Golem: From Earth to Outer Space." *Leonardo* 39, no. 2 (2006), 117–124.

———. "Process(ing) Interactive Art: Using People as Paint, Computer as Brush, and Installation Site as Canvas." *Leonardo* 24, no. 3 (1991), 285–288.

———. "Smell Your Destiny: Web Interaction with the Fifth Sense." *Leonardo* 37, no. 3 (2004), 183–186.

———. Sonya Rapoport website: http://users.lmi.net/sonyarap/.

———. "The Transgenic Bagel: The Transformation of Computer-Based Artwork." *Leonardo* 31, no. 4 (1998), 271–275.

Rapoport, Sonya, and Dorothy Washburn. *Interaction: Art and Science*. New York: Truman Gallery, 1979.

Reckitt, Helena, and Peggy Phelan. *Art and Feminism*. New York: Phaidon, 2001.

Rorimer, Anne, "Approaches to Seriality: Sol LeWitt and His Contemporaries." In *Sol LeWitt: A Retrospective*, ed. Gary Garrels, 61–71. San Francisco: San Francisco Museum of Modern Art, 2000.

Rosler, Martha. *Decoys and Disruptions. Selected Writings, 1975–2001*. Cambridge, Mass.: MIT Press, 2004.

Skrebowski, Luke. "All Systems Go: Recovering Jack Burnham's 'System Aesthetics.'" *Tate Papers*, Spring 2006: http://www.tate.org.uk/research/tateresearch/tatepapers/06spring/skrebowski.htm.

Sonya Rapoport: Interfacing Art, Life, and Family: Some Views from Close at Hand

Hava Rapoport

One remarkable and intriguing aspect of Sonya Rapoport's art is the many ways in which she integrates her creative process with her life and surroundings. She draws on everything around her for the inspiration and ideas that are incorporated into her pieces. She doesn't merely absorb ideas, however: they also move outwards as she transmits back to those around her. Family and home life are valued parts of her life and intertwine with artistic expression on different levels and in multiple ways: specifically, her life and her family provide subject matter and influence her modes of expression.

As Sonya's daughter, I have had the opportunity and privilege to live with her and to experience this art-life-family interface. I will explore some examples that are dear to me, and I will share some of my views and interpretations of Sonya's works and creative process and mention their influence on my own life.

The Family Table

At dinner, around the table, there was often discussion of what it means to be creative and the challenge of creative activity and expression. My father, Henry Rapoport, was a chemist, and my mother is an artist, but they both believed in the universality of creative pursuit. The family dinner table was the time and place where they would describe to us how they were confronting their current challenges and situations, and they would encourage my brothers and me to comment and to present our own.

While growing up it was a very special privilege to listen to my father Henry's explanations of how to approach scientific research by the logical interpretation of observations, and his ideas about the next relevant questions. He described his own

challenges in ways that the whole family could understand, and this was consistent with his firm belief, frequently repeated to us, that if you really know what you are doing, you can explain it at any level. Recently, reminiscing about our family's past and its relation to Sonya's incorporation of scientific ideas and images into her work, I asked her, "Do you think our dinner table discussions influenced you, that they made science more accessible and even alluring to you?" Her answer was immediate and definitive: "Oh, that was the beginning of it all."

Themes and Forms Gleaned from Daily Life or Learned from Contact with Others

1. General Subjects

My mother Sonya's incorporation of common objects in her artwork always seemed natural to me. From a very young age my brothers and I were taken to numerous museum and gallery exhibitions, willingly or not, where I saw many everyday articles displayed, probably the most famous of which was Marcel Duchamp's toilet.

 The everyday objects she uses are generally simple, unpretentious items, things commonly owned and encountered. Although she incorporates (appropriates, in artists' and Sonya's own terminology) these items throughout her different works and

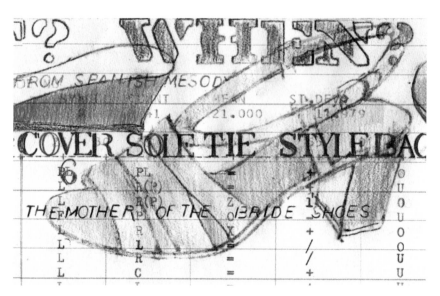

Sonya Rapoport
Mother of the Bride's Shoe (detail of *Bonito Rapoport Shoes,* panel 3),1978
Transfer print and colored pencil on continuous computer form, 110" H x 15" W

Photo of Hava Rapoport and her husband, Elias Fereres Castiel, as an *Object on My Dresser*, 1979–1984
Cofey print collage, 6" H x 9" W on continuous computer forms

styles, they are fundamental components in the project series *Objects on My Dresser* (see Plates 7 through 24) and *ShoeField* (see Plate 25 and Plate 26). *Objects on My Dresser* incorporates a mixture of photographs and keepsakes, gifts from family and friends, and household items, all of which struck visual aesthetic notes or content cues for Sonya. The *ShoeField* pieces were based on approximately forty pairs of her own shoes, and after the installation went interactive, it incorporated participants' shoes. Another good example of this is *The Transgenic Bagel* (see Plate 27), which integrates a bagel and the everyday action of slicing with recombinant gene splicing. In parallel with her use of common objects is Sonya's appropriation of newspaper and magazine photographic images in the 1970s for collages on computer printouts and later for webworks and blog pieces.

Many of the objects she uses are personal, and personally meaningful. This is clearly evident in *Objects on My Dresser*, which includes objects related to my siblings and me: some batiks I made and a picture with my husband; a chess set from my brother David; and a tray and jewelry box from my brother Robert. Sonya also identifies strongly with female symbols, such as the ubiquitous uterus shape she used in the *Survey Chart* series and the sprayed and stenciled paintings that followed.

Sonya interprets these appropriated objects in relation to their aesthetics, their meaning, or, most frequently, a combination of the two, often giving them new or

expanded contexts. She commonly relates shapes, forms, colors, or other visual aspects, for example the round shape and concentric circular ridges of furniture coasters to a circular labyrinth, or the spiraling forms of ears and seashells. She also focuses on meanings, for example by correlating my photograph in Spain with an El Greco self-portrait. Sonya also considers physical material and source in her various comparisons.

2. Scientific Themes

Sonya frequently interfaces her work with scientific procedure and computer-based analysis, often by collecting data about one component of the piece and then plotting it. She uses this analytical approach in an archaeology-based collaboration with Dorothy Washburn; in *ShoeField;* and in web plots for *Objects on My Dresser.* Likewise, Sonya's numerous interactive computer works and Internet pieces employ links and hierarchies to organize and present data.

Sonya incorporates many images and concepts from different scientific fields, including chemistry, genetics, entomology, ichthyology, botany, and anthropology. A principal source is chemistry, my father's field of work. Her ready access to these images probably began with my father's work, which he loved and which provided challenge and stimulus to his life. But Sonya extended her search to other areas of chemistry: the periodic table of the elements; NMR (nuclear magnetic resonance) output; nuclear decay schemes; and the hexagonal carbon ring. She also explores chemical concepts of symmetry, left- and right-handedness, and cis-trans isomerism, which also fascinated my father.

I work with plant growth, development, and reproductive biology, particularly

Sonya Rapoport
Make Me a Jewish Man: An Alternative Masculinity (ovary on left disempowering the unicorn on right), 1998–99
Interactive website, Variable size

in crops such as sugar beet, alfalfa, and the olive tree. Sonya was interested in different ideas and images associated with these subjects, notably olive tree morphology and olive oil production, for *Make Me a Jewish Man*. I explained these ideas to her and provided her with resource materials; in our interchanges she was an active, insistent questioner. I also was a source for other biological ideas, such as gene splicing (*Transgenic Bagel*) and the pandanus tree (*Arbor Erecta*).

These interactions with my mother were special. She was interested in hearing and learning as much as possible about the subject at hand, but she always treated it in her own way, giving it her own particular twist. To me, this twist indicates her creativity, the result of channeling ideas and newly expressing them. She opened my eyes to how science and scientific pursuit appear to nonscientists and encouraged me to examine and define my own views on these issues.

One important component of many of Sonya's artworks is their backgrounds. These backgrounds are not just material supports: they are important factors in the aesthetics and meaning of a piece. They range from common daily materials, such as calendars, wallpaper, and cloth, to more technical materials, such as geological survey charts (a fortuitous find in the drawers of a surplus University of California cabinet). Other technical sources include charts from nuclear chemistry, NMR output readings, and the periodic table. The ubiquitous early computer printouts were gleaned from the UC Berkeley mathematics department's recycling bins or from my UC Davis agronomy department research group and colleagues.

It was always fascinating to me how the background elements—originally imported, essentially prefabricated forms and structures—evolved beyond and "escaped" their background roles, bleeding into multiple layers of the different pieces. This interactive, dynamic layering is a trademark of Sonya's and can be seen consistently in all of her different styles.

My Quilt and the Egyptian Expressions

It is likely that my love of quilting derives at least partially from my mother's aesthetic influence. Much of my work as a scientist centers on shape and form, a focus that I feel was strongly influenced by the love of image and shape that Sonya transmitted to me while I was growing up. The quilt that I made for my parents is a special example of my mother's and my shared interests and ideas. It incorporates pieces from an installation by Sonya, as well as other elements and images related to her artistic activities and works.

Sonya produced a series of artworks involving Egyptian deities and the Ka (the vital force), which I think of as the "Egyptian Expressions." One interactive installation in this group, shown at the Ghia Gallery, included black satin pillows silk-screened in gold with images of Egyptian deities; traditional paintings of those deities; gold balloons with the deities printed in black; words of power contained in beakers placed in caskets; and an interactive computer program, *The Animated Soul: Gateway to Your Ka*.

I started my quilt with its center, a black silk-screened print on peach-colored

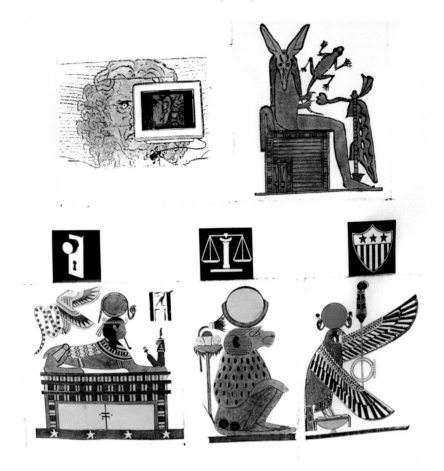

Sonya Rapoport
The Animated Soul: Gateway to Your Ka: Wisdom, 1991
Blueprint and Prismacolor on vellum, 40" H x 36" W

Photo by Marie-José Sat

satin by Sonya's colleague and dear friend Vance Martin. Sonya asked me to set this piece, given to her by Vance, in a quilt. I agreed but also convinced her to let me use some of her silk-screened Egyptian deities, which were similar in medium but provided a fascinating color and design contrast with the central piece. In the finished quilt, ten Egyptian deities form blocks along the quilt's sides and base. The blocks and central piece are tied together by strip-pieced sashing, including remnants from a period when Sonya was using wallpaper and upholstery fabric samples as backgrounds. The quilt lining incorporates fabric printed with shoes for *ShoeField*. I constructed the quilt primarily during summer visits to the family home in Berkeley, and my mother closely observed, critiqued, and admired every step.

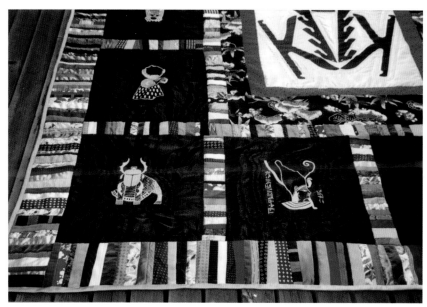

Photo by Marie-José Sat

Hava Rapoport
Quilt based on *The Animated Soul,* 1991
Silk quilt with silk screen and a print by Vance Martin silk-screened at center, 108" H x 96" W

Hava Rapoport
Quilt based on *The
Animated Soul* on
bed, 1991
Silk quilt with silk
screen and a print by
Vance Martin silk-
screened at center,
108" H x 98" W

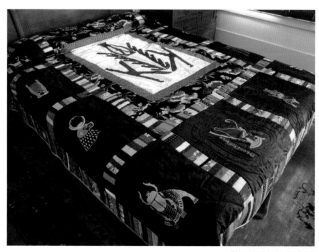

Photo by Marie-José Sat

A Throw of the Dice: Between Structure and Indeterminacy

Richard Cándida Smith

> Having survived Art 2A [Composition], I eventually landed in Cyberspace. I have been asked "why" many times; and every time I give a different answer. I really don't know "why." It was by no means a direct route nor a quick decision. —*Sonya Rapoport* [1]

I met Sonya Rapoport while helping to organize an oral history project with alumni of the Department of Art at the University of California, Berkeley. Having written on Jay DeFeo, one of the department's better-known graduates, I was well aware that by the mid-twentieth century, the department had become one of the most highly ranked studio art programs in an American research university. Its graduates included an unusually large number of artists who developed national and international reputations, including Sam Francis, Robert Colescott, Fred Martin, Pat Adams, and Sonya Rapoport. Graduates from the program uniformly acknowledged the importance of its approach for their later careers, even though they also typically complained of the training they received as being somewhat narrow and rigid. Nonetheless, their teachers at Berkeley taught them to think about visual structure in a rigorous manner, to understand that painting was a form of communication with its own vocabulary and grammar.[2]

 I conducted an interview with Sonya Rapoport about her master's program in painting at Berkeley and what she learned from her teachers. "My whole life's work," she affirmed, "is based on my training from Berkeley. The fact that they were able to verbalize what went here and what went there, and why, and why it was right."[3] As a result of my concentrating on her training, my starting point for thinking about

24

Sonya and her work has been opposite that of other scholars, who have rightfully concentrated on Sonya's role as a pioneer in digital art since the 1960s. In this essay, drawing upon our videotaped conversation as well as other sources, I examine how her formalist training as a painter can deepen understanding of her later work in media that by their nature are more open-ended and indeterminate.

The key phrase in the Berkeley art department curriculum was *formal structure*. Erle Loran's course on Cézanne's compositional techniques was required for all students, while Loran's book *Cézanne's Composition: Analysis of His Form with Diagrams and Photographs of His Motifs*, published in 1943, was the art department's bible.[4] Loran had spent a year living and working in Cézanne's studio outside Aix-en-Provence. He carefully photographed the original scenes of Cézanne's most famous paintings, attempting to duplicate the painter's viewpoint. The book provides a careful analysis of Cézanne's reshaping of his scenes to create imaginary spatial forms on two-dimensional, colored surfaces. Loran delineated the "grammar" Cézanne used to recreate what he saw into completely realized paintings, the psychological depth of which was grounded in an absolutely rigorous formal structure that, in the words of one late-nineteenth-century critic, functioned "less as a painted picture than as a diagram of ideas."[5]

The prime lesson Loran emphasized was to bring all the elements within a painting back to the picture plane, "the flat surface of the painting defined by the two dimensions of the frame, height and width." The imaginary depth suggested on the picture plane comprised the "negative space" of a painting, while a "negative shape" was the ground upon which identifiable shapes were placed. Movement into and back out of negative space created the emotional rhythms of a painting, but the unity of the work required always returning the eye to the picture plane. Spatial relations depended on the use of color as the instrument for creating "an inner light that emanates from the color relations in the picture itself, without regard for the mere copying of realistic effects of light and shade. The color always remains two-dimensional; it lights up the picture plane."[6]

Loran was proud that what Berkeley had to offer was a procedure that was at once technical and psychological: "You put down flat and open areas of color," he stated in an interview. An open area suggested but did not define a shape. "So that the total picture, when most all of the color is laid out in simple, flat areas, the whole thing is unified with the picture plane."[7] Despite the emphasis on formal structure, the Berkeley art department faculty were not interested in form for its own sake. Loran recalled Hans Hofmann's stern advice that "everything has to come from nature, otherwise you just defeat yourself into style. That's what he said to Pollock… when he first started doing the dripping."[8] Establishing spatial relationships on a two-dimensional surface was the necessary condition allowing for visual communication, but the composition of mark, form, and line served the goal of reaching out to viewers with ideas and feelings that could make them think about the human condition in dramatically new ways. The world that emerged through the intelligent interpretations of the creative mind was more deeply real, more enduring, more valid

than the world of casual appearances and independent of the whims of fashion and style. Painting was a technique without equal for revealing the fundamental conditions of consciousness.[9]

Central to Erle Loran's conception was an assumption derived from Alberti that a painting or a graphic object is seen all at once. The overall structure presents itself first, and then on deeper examination the details that establish the structure appear. Classic painting had submerged structure within the anecdotal detail of the story the painter was representing, with the danger that clarity was lost in stylistic flourishes. Storytelling undermined the sober investigative work that ought to be the heart of the painter's task. Loran thought, for example, that Francis Bacon, among the best-known of post–World War II painters working with images, "is no painter at all but a melodramatic, cheap storyteller with little feeling for paint, color, and often incredibly gauche compositions!" Abstract painting escaped "storytelling" by making the foundations of visual communication the content of the work, but with the danger that as forms are reduced to their most basic elements, artists lose their power to convey complex experiences and painting becomes monotonous. Loran believed that the crisis of painting after Abstract Expressionism reflected an inability of artists to coordinate form and communication. Purists like Reinhardt and Rothko eliminated everything but basic color, so the content of work was only about the raw experience of painterly elements. Pop artists relied on irony to distance themselves and their viewers from any reality their images might index. In both cases, ideas about the world disappeared into empty celebration of painting for painting's sake. If there was anything to learn from the most successful contemporary artists, it was simply technical. Loran, after viewing an exhibition of Pop art, wrote Sonya that Andy Warhol's use of a particular brand of paint "would solve your problems because although it dries fast to the touch, you can wash it out with great ease. It remains highly soluble for a long time. With Magna you would have a combined advantage of the look of acrylic, the weight of oil, the lack of need to prime the canvas and the ease of washing out your screens."[10]

I asked Sonya how Loran's teachings about Cézanne's compositional technique translated, if at all, when she moved from a framed, two-dimensional image to work that no viewer could possibly ever take in all at once. Sonya's response settled on *Objects on My Dresser* (1979–1983; see Plates 7–24) as an example of a pivotal work for her that had eleven distinct phases in its development. At one point in the course of the project she incorporated Loran's diagrams, a key element of her formal training, into the structure of the piece. This technique for a period was applied in a number of projects in which she reworked computer printouts with visual overlays that converted them into handcrafted art objects.

On their relationship to the Berkeley art department's pedagogy, Sonya said:

> These diagrams are classic expressions from the Berkeley School,
> originating with Hans Hofmann, all this is a system of holding
> an image in abeyance. I took each diagram that Erle Loran had
> illustrated with a Cézanne image. So first, these are all the objects

on my dresser.…I'm beginning with a picture of the objects on
my dresser, and showing what Cézanne would have done with
those objects. So I have a diagram of one of his paintings. But it's a
diagram. It's a diagram made from one of [Erle Loran's studies] to
show how the movement in a painting circulates and doesn't get
lost in perspective. This diagram is superimposed upon the picture
of objects on my dresser. Now we're going to the simple objects that
abide by these concepts. First was the two-dimensional object.…
You see the arrows of this two-dimensional. I think I'm answering
your question how the Berkeley system is evolving into applying
something conceptually, and using a narrative.[11]

Objects on My Dresser in its first manifestation presented personal objects that the
artist then interpreted, or "put in abeyance," through a visual code that had been
of personal importance to her but also a highly formalized effort by a university
professor to understand why paintings were able to communicate spatial relations in
a predictable way. Sonya continued to add additional layers of meaning in a process
that would eventually lead to a performance piece inviting an audience to add their
own layers of meaning:

I had twenty-nine objects on my dresser. In order to make
them more exciting, I attributed a correlative object. I assigned
a word to the object, a word to the correlative object. How did
these objects, the words from these objects, relate to each other?
That was my interest in language. This was a correlative object,
two-dimensional, parallel to the picture plane. So this correlative
object was an image that was static. It was flat against the picture
plane. Nevertheless, its relationship, if you put it on the floor,
would make it dynamic.[12]

She created graphic representations of audience response to the objects,
computer-generated images that shared some of the formal characteristics of Loran's
diagrams, which of course had already been placed into the initial stage of the work.

Whereas here is a dynamic image against the picture plane. It
unfolds in more of a dynamic way, rather than a two-dimensional
way. Then we go into overlapping planes. All my work is overlap-
ping. Not all my art will happen conceptually, but it's overlapping
pictorially. The diagram is overlapping on the object. The printouts
are overlapped with language designs and pictures. Whether this
was inculcated in me to develop further, I don't know.[13]

A formal structure was unfolding across time through overlapping chains of per-
ception and response involving both the artist and her viewers.[14] The elements in
the work were logically derived, but the structure of Sonya's ongoing piece was not

entirely predictable. Viewers responded to the objects and their correlative attributes in individual ways. By incorporating their responses into the form of the piece, Sonya made indeterminacy a necessary element of the work as a whole. Viewer responses could be plotted into graphic patterns that seemed to have strong echoes of Cézanne's dynamic patterns. She could plot graphs representing the affinities and predispositions of distinct professional groups with different approaches to analyzing and interpreting the worlds in which they lived. Whether the resemblances between computer-derived graphics and pictorial dynamics postulated as the foundation artists use to create communicative visual structures were purely accidental or revealed some underlying Goethean principle that aesthetic form emerges and develops from underlying "original phenomena" is not answerable at this time.[15] Certainly, the resemblances are suggestive, but Sonya's work did not set up its problem in either scientific or philosophical terms. Sonya recalled, "I wanted to express my feelings and use my language code…still abstract, but going into the reality around me."[16] She used the patterns that emerged to present a conceptual "portrait" of twentieth-century American subjectivity through images that were intended to provoke audiences to think about their own responses rather than offer a generalized and generalizable definition of contemporary states of mind.

Sonya's computer-based work grew from a decision to explore how scientific and artistic practices might intersect. She made this decision shortly after her midcareer exhibition at the Legion of Honor in San Francisco in 1963. At this time she began exchanging ideas with scholars on the Berkeley campus, many of whom she had

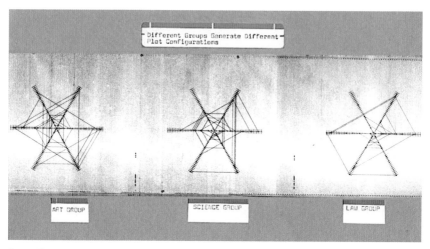

Sonya Rapoport
Objects on My Dresser (supporting document): "Different Groups Generate Different Plot Configurations, Art Group, Science Group, Law Group," 1979–1984
Calcomp plot and labels
12" H x 26" W

known socially over the years, since her husband was a prominent professor in the Department of Chemistry. She met with nuclear physicists from the Lawrence Laboratory, who gave her the computer printouts from their experiments in constructing artificial gold molecules, an achievement that appealed to her long-standing interest in alchemy as a symbol of creativity. She talked to chemists working on plant photosynthesis at the Melvin Calvin Laboratory, as well as to mathematicians, botanists, psychologists, and anthropologists. Like their colleagues at the Lawrence Laboratory, many of these scientists gave Sonya computer printouts and other records of their work. The computer printouts proved to be a particularly compelling if challenging visual form. The translation of experimental observations into meaningful visual patterns from which scientists could deduce the generalizable conditions of a phenomenon challenged her to think more deeply about the lessons she had learned as an art student about form. Structure in this format was conceptual rather than derived from the dynamics of marks on a two-dimensional plane.

"Visual was no longer the most important thing," she said of this period of rethinking graphic representation. "I just had to understand the programming."[17] Nonetheless, her original training proved important as it led her to read printouts in a distinctive way based on her own professional understanding. Washburn's computer programs, for example, analyzed the development across time of symmetrical patterns used in Anasazi and other ancient southwestern Native American ceramic pottery. Sonya's rereading of Washburn printouts of sandal designs used in images decorating the pottery surfaces led to an important discovery that might have otherwise passed unnoticed:

> With Dorothy Washburn, it was not only deprogramming her symbols of designs—she used the comma as a way to designate a pattern of early American Indian pottery. I had to take that comma, and then I had to find out how that comma related to the pattern. What went on top was a decoding of early American Indian pottery design. But accidentally, I discovered an image of a sandal, a ceramic foot effigy, amidst all these shards. The sandal style was not of the sandal style that the American Indians used. We're talking about the year 1000. Now, how did that foot effigy get into New Mexico? They found it was a Mexican sandal, and trade relations had been established because of that discovery. But I was really interested in the sandal, all of the different styles of the sandals, where they came from and how they related to the tribes. That's when I had my first shoe performance, asking people about their shoes. Why did they wear them? Why did they wear them that evening? How did they like them? Where did they buy them?…I must say that after investigating American Indian sandals, I investigated my own shoes, and asked these questions.[18]

In the course of a collaboration that extended over several years, Washburn discovered that she had an opportunity to observe and analyze the steps of what she as an anthropologist called "the creative process" through Sonya's efforts to recapitulate and then internalize the forms that the computer printouts documented. She gained insight into how fabricatory processes affected the "arrangement of forms in space and colors with forms." In order to express culture, artists had to arrive at solutions to how to organize the structure of works they made, questions that were inseparable from the materials and the technical apparatus available to the artist/artisan. Washburn determined that the sum of the parts was more important than the parts themselves, that is, arriving at an overall formal arrangement was more important than the individual motifs, because a complicated set of interrelated problems had to be solved for cultural expression to occur in the first place. The motifs were the pregiven cultural elements present in a society, but the practical needs to express them in given materials using particular technologies opened a space for visual innovations that were at times independent of preexisting cultural values but could then be incorporated into cultural repertoires. Working with Sonya allowed Washburn to see how art as a production process intersected in unpredictable ways with art as a system of cultural communication.[19]

For Sonya, on the other hand, computer printouts were "ritualistic symbols" revealing the identification modern societies had developed with technology. As she became more comfortable with computer processes and the insights they provided into the relationships that forms took in particular situations, she discovered computers could be a useful tool for reflecting more deeply upon objects from her own personal, everyday life. Computer-based analysis of visual structures allowed her to engage her interests and passions as artist, wife, and mother in ways that painting had not. In the process she explored how indeterminate content reflecting her interests and those of her viewers could provide formal structural principles governing this new work.[20]

Mirror of Nature

The images she found might stimulate a clearly personal, idiosyncratic response, but the work also often took more impersonal directions, particularly when abstract symbols became a prominent feature in a work. Discussing *Pandora's Box* (see Plate 1), Sonya noted:

> On the right is a section cut off from a fleur-de-lis rest. It resembles a fetus. The long horizontal image is made up of a cross section of a uterus belonging to an anatomy toy set. When the uterus template is superimposed on itself upside down, an X is formed. The X symbolizes the extra chromosome that the female carries. With two X's placed side by side and mirror-reflected horizontally, a broad O, a mandala (egg) shape portending life and eternity, is created in the space between the X's. This imagery implies birth and rebirth.[21]

Sonya Rapoport
Mirror of Nature (detail), 1977
Transfer print and colored
pencil on continuous
computer printout containing
experimental research from
Melvin Calvin laboratory
110" H x 15" W

Her formal training remained part of her work process, an approach inseparable from her identity as an artist. She continued:

> I first described each piece in a two-dimensional format that was quite a complete artwork in itself. An example of such an artwork would be *ShoeField* (see Plate 25 and Plate 26), which I started in 1977. In this work about American Indian designs and sandals, I superimposed drawings on the computer forms that related to the anthropological research that was encoded in computer printouts. For the first drawing overlay, I decoded the printout with symbols, drawings, and words and then added imaginative relevant material as a second overlay on the form's surface. I repeated this process with my own collection of shoes. These continuous computer forms upon which I delineated the drawings completed the two-dimensional artwork with which I anticipated an interactive happening—in this case *Shoe-In*, which took place in 1982.[22]

Her interest in shoes led to her first venture into using the programming of computer data to create visual forms:

> I started quantifying qualitative information. I put a number on
> how they liked their shoes and where they got their shoes and so
> forth. I had a lot of numbers. And they had a shoe charge compiled
> from these numbers. Each one was given a shoe charge number,
> a shoe color; a pattern came from this, on the computer. At that
> performance, there were seventy-six people. I put the data into
> a—I didn't put it in, I had a programmer—put it into a magnetic
> field program, where you could see all the participants, each
> one represented by a tilde. The people were actually given two
> numbers: their entry into the space and their final charge number.
> And these two were calculated into a magnetic field program.[23]

The forms her program made visible had little to do, either conceptually or practically, with the objective purity of abstract painting, at least as understood in the 1940s and 1950s. Working with new materials and new technological procedures, Sonya had to move away from the notion she had learned as a painter that a structural foundation was necessary to fix the placement and treatment of all the elements in the composition. She had entered a world of provisional propositions allowing sequences of forms to appear, develop, and fade away. The work emerged in a continuous reshuffling of inputs, which could be feelings and responses, if that is what the artist chose, or they could be objects, forms, or images. Or the inputs could be audience-generated responses, which, even if they fell into regular patterns, were by definition unknown and unpredictable at the outset. Any of the input sets could be organized into a coherent visual pattern, if she chose to do so, since chance is probabilistic rather than random. In earlier visual media, gradation had been continuous and infinite. Each element was chosen from a spectrum that seemed either inherent to the pictorial situation (as in a photograph) or to relate to abstract and universal laws of color and light (as in theories of painting and/or visual structure).

Technology serves as an "objective" condition for the expression of ideas about the world. It is a mode of representation, but not a limit to perception with the five senses. New ways of representation allow explorations of reality driven by the competitive discovery of what can be said, a competition driven by the simple reality that no single output will or can ever fully express what the inputs have to say. The end result has been a body of work that rediscovered Stéphane Mallarmé's argument that expression is always creative but always ephemeral. The classics attempted to make palpable the values a society needed for its members to live correctly and therefore "justly," the master of symbolism acknowledged. The method, starting with perspective, endowed those values with a logical coherence that suggested they were eternal. Art historians have long understood that the reality effect of Renaissance perspective paintings rested on the paradoxical fact that nobody ever could see the pictures presented. Perspective served as a symbol of power precisely because its reality was

ideal and not empirically verifiable. Its tests pertained to laws of geometry and optics. Perspective served power well because it naturalized a vision that could belong only to those who stood outside and above everyday reality. It brought before the public the apparent power to command vision to be orderly and hierarchical.[24] The trouble with the classic modes of representation that modern artists inherited is that every constellation of thought is impermanent and imperfect.

Mallarmé's observations puzzled his contemporaries at the end of the nineteenth century, but in the twenty-first century, they have become more understandable, if still controversial, as Web-based communication has become an integral part of everyday life. Sonya has been making art with websites since the 1990s. The medium has allowed her to explore her ideas in parallel sets of variations unfolding over many years. Sonya has discussed in detail the recurrent images and themes within her Web work, what those images mean to her, and their relationship to her earlier explorations of digital art and indeed to concerns she had when she worked as a painter. Other essays in this volume explore and interpret these themes, locating them in the history of new media and contemporary art.

Rather than reiterate what Sonya and her critics have stated with exceptional clarity, I will conclude by going back more deeply in time to a period when digital art did not yet exist but the proliferation of mechanical forms of pictorial reproduction had already led many to question how stable cultural values could persist in a world where images circulated freely. My observations on the tension between structure and indeterminacy at play in digital art forms are in large part derived from an earlier study of Mallarmé, whom I view as a foundational figure for a contemporary culture able to examine critically the conditions governing communication. The work of Sonya Rapoport is a particularly useful starting point for thinking about these problems because she personally was formed in a school that was deeply committed to the principles of classical culture, that is to say, to the necessity of a logically determined structure for saying anything intelligent. The value of her training was clear to her, even if in many respects her teachers were at odds with the leading trends of twentieth-century art. As she migrated to new media, she had to rethink the discipline that the Berkeley method inculcated in her, in order to embrace a more open-ended understanding of how systems develop. Consequently her ideas of what "structure" involved had to change.

Mallarmé, too, looked back with a certain degree of regret for the days when humanity could credibly seek a more certain understanding of the universe into which they had been thrown. But the structure of things proved to be as fluid as thought.[25] In his last published work, "Un coup des dés," Mallarmé proposed that every thought is a roll of the dice, not like a roll of the dice, but actually a gamble that brings into sight another way of being in the world. Every thought is a proposition about what the relationship is between "me" and everything else. "As if" is the only law that can be revealed, since every statement is unique and something will emerge *momentarily* to take its place. Every thought is the kernel for a new mind, which, if it shoots out roots, becomes a new form of life. Most do not because most propositions

cannot pass the test of leading to a life that would be better or, more tragically, are not in the realm of possibility given the conditions of the moment.

This suggests that artistic exploration is no utopia, but merely, as Mallarmé frequently insisted, a place where laughter rules. The "as if" is almost always a ridiculous proposition, which is not to say unhappy or worthless. The "as if" returns to the absence that poetry invokes, that is, the absence of the absolute, the explanation for *what* is that will never be found. Since every manifestation vanishes, it is a mistake to confuse appearance (what exists *for* us) with what is. Fundamental reality remains absent and out of reach. The mind pushes forward in a persistent search for ways to grasp what is inherently ineffable. In the process, creative interpretation, that is to say poetry, becomes the basic and most important condition of humanity's developing relationship with the universe. As Mallarmé put it, "Nothing will have taken place except the place." The "as if" is ephemeral, but if it prompts the formation of a longing, the imagination is taken up with unfulfilled possibilities. If enough individuals share similar unfulfilled longings, a social transformation is in the works, as the ways people feel will change. Alternatives, however comical they might seem at first, have been injected into the dreams of a society. They will spread, and the stability of what *was* (in actuality only what seemed to be) dissolves into desires for new possibilities that enter the repertory of cultural predispositions.

The future that will emerge from this unceasing activity must remain unclear, a supposition, a guess, a preference. The uncertainty and unpredictability of the future is a logical corollary of its nature as a permanent absence from the present. An absence can never be a presence, though it may be felt and intuited. When we imagine, as the great writers and artists of the nineteenth century did, that past, present, and future can be known with certainty, that they exist in a determinable structure *as if* there were a law assuring the permanence of our guess, we lose whatever hold on the present we can have, for we have created an absence for ourselves that is false. We have condemned ourselves to a form of perdition. In terms of creative expression, Mallarmé thought that every new art form appears at first as a "half-art," an "almost-art," or "what merely verges on art."[26] The excitement new art causes is a result of its overturning ideas that had once seemed certain, and in compensation experience is refreshed and people gain a broader, more critical view of themselves. The loss of certainty is not to be celebrated, he conceded, as modern men and women have lost the clarity that myths provided their ancestors, with symbols that provided meaning to every aspect of daily life. But to imagine absence as presence when one has discovered that the desired (the ultimate) is in fact out of grasp is a form of self-alienation. Perdition becomes self-chosen degradation instead of a tragic fate accompanying each person who will eventually face a day when accounts must be reckoned and the effects of a fundamental ignorance confronted.

The search for the absolute must always end in shipwreck, though in the process we become whoever we might be. Creativity and destruction are simultaneous because what humans create evaporates almost instantly. What the absolute (the absent that can be intuited but never known directly) creates is replaced continually

as well. There might well be meaning in all phenomena, but it is what men and women bring to everything they encounter; the significance of all things is for us rather than for what we describe. The "let there be…" is an all too human imagination of what an imagined Master might have done at some point in the activity accompanying Creation if the divine had been acting according to our rules.

Human imagination unfolds in a continual outpouring of spoken, written, visual, and performative activity, all of which can be considered forms of poetry. Something will be said. Others will pay attention. A statement lives only insofar as it is repeated, and the poem grows as its recipients repeat it in a way that makes it their own. Every statement is inadequate as a complete and permanent, structurally determined description of external reality, but even still our responses and our understanding have changed in the course of an encounter that captures our attention. So much is said every day in so many forms—aural, visual, textual, intellectual. In the days of "high culture," we relied on experts to direct our attention. With the introduction of the Web, we are learning to rely on algorithms, and the chance patterns of what attracts our attention. Chance has become more evidently the driving force of exchange, and the process has become more clearly subjective. Why pay attention, why not? How does one select from what is out there—not even asking for attention other than existing and having been coded in various ways to respond to different types of searches—other than to rely on the ebb and flow of personal attraction?

Notes

1. Sonya Rapoport, "Sonya Rapoport History: An Annotated Compilation of the Artist's Work," *etherart.net*, 2006, http://etherart.net/srhist/hist1/index.html.

2. For a more extensive discussion of the curriculum developed in the Department of Art at the University of California, Berkeley, in the 1940s, see Richard Cándida Smith, *The Modern Moves West: California Artists and Democratic Culture in the Twentieth Century* (Philadelphia: Univ. of Pennsylvania Press, 2009), 59–65.

3. Sonya Rapoport, "Art Department Alumni at the University Of California, Berkeley Oral History Project: Sonya Rapoport," 2006 interview by Richard Cándida Smith, Regional Oral History Office, The Bancroft Library, Univ. of California, Berkeley, 51; available online at http://bancroft.berkeley.edu/ROHO.

4. Erle Loran, *Cézanne's Composition: Analysis of His Form with Diagrams and Photographs of His Motifs* (Berkeley: Univ. of California Press, 1943).

5. Gustave Kahn, "Seurat," in *Symbolist Art Theories: A Critical Anthology*, ed. Henri Dorra (Berkeley: Univ. of California Press, 1994), 173.

6. Loran, *Cézanne's Composition*, 29.

7. Erle Loran, "Interview with Erle Loran," interview by Herschell Chipp, June 18, 1981, Archives of American Art, Smithsonian Institution, 73.

8. Ibid., 80.

9. A student of Loran's in the late 1940s who became a good friend of his, Sonya Rapoport recalled that he gave everything a psychological twist (discussion with artist, at her home in Berkeley, California, 12 December 2003).

10. On the Berkeley approach to spatial relationships see Sonya Rapoport, "UC Berkeley Art Department Alumni Oral History Project," 17–22; see also Erle Loran to Sonya Rapoport, 13

October 1961, 18 July 1964, and 8 November 1964; quotations from Loran to Rapoport, 4 April 1956, 2 July 1969 (Loran's letters in Sonya Rapoport's personal papers).

11. Sonya Rapoport, "UC Berkeley Art Department Alumni Oral History Project," 60.

12. Ibid., 60–61.

13. Ibid., 63.

14. Ibid., 63–69: the process is briefly sketched here. See also Sonya Rapoport, "Sonya Rapoport History: An Annotated Compilation of the Artist's Work," 3:17–33; and Meredith Tromble, "The Advent of Chemical Symbolism in the Art of Sonya Rapoport," *Foundations of Chemistry* 11 (2009), 54–56.

15. In 1977 Sonya, as part of a collaboration with James Bennett, a postdoctoral student in agriculture at the University of California, Davis, prepared a computer-printout-based work, *Goethe's Urpflanze,* which explored elements of Goethe's morphological theories.

16. Sonya Rapoport, "The UC Berkeley Art Department Alumni Oral History Project," 50.

17. Ibid., 53.

18. Ibid., 53–54.

19. *Interaction: Art and Science,* exhibition brochure, Truman Gallery, New York City, 1979; Dorothy Washburn, draft for an introduction to an exhibition of baskets by Native Californians in the collections of the University of California, n.d. Both documents in papers of Sonya Rapoport. Washburn's conclusions closely resemble the arguments that George Kubler, an historian of Iberian and pre-Columbian cultures, made in his well-known book *The Shape of Time,* published in 1963.

20. Sonya Rapoport, "The Process of Creating New Media: Interview with Sonya Rapoport," interview by Judy Malloy via email in November 2009, http://www.well.com/user/jmalloy/elit/rapoport.html. See also Rapoport's statement in the *Interaction: Art and Science* brochure.

21. Rapoport and Malloy, "The Process of Creating New Media."

22. Ibid.

23. Sonya Rapoport, "The UC Berkeley Art Department Alumni Oral History Project," 54.

24. For perspective, see Norman Bryson, *Vision and Painting: The Logic of the Gaze* (New Haven, Yale Univ. Press, 1983) and Erwin Panofsky, *Perspective as Symbolic Form* (New York: Zone Books, 1991).

25. For an analysis of Mallarmé's work as an effort to replace ontological conceptions of consciousness and cosmology with fluid semiotic systems, see Laurent Jenny, *La fin de l'intériorité: théorie de l'expression et invention esthétique dans les avant-gardes françaises (1885–1935)* (Paris: Presses Univeritaires Françaises, 2002) and Richard Cándida Smith, *Mallarmé's Children: Symbolism and the Renewal of Experience* (Berkeley: Univ. of California Press, 1999).

26. Terms cited come from Harry Weinfeld's translation of Mallarmé's preface to "Un coup des dés" in Stéphane Mallarmé, *Collected Poems* (Berkeley: Univ. of California Press, 1994), 122.

A Conversation with Sonya Rapoport
(on the Interactive Art Conference on Arts Wire)

By Anna Couey and Judy Malloy

The Interactive Art Conference was an online laboratory for focused discussion and production of interactive art founded by Anna Couey and Judy Malloy in 1993. Defining interactive art as: "involv[ing] exchange between its originator, work, and participants," the Interactive Art Conference hosted a virtual artist-in-residence program that provided artists a forum to discuss their work and their exploration of interactivity. Discussion topics covered a broad range of interactive art media including: computer-mediated literature, social sculpture,[1] art telecommunications,[2] electronic art, artists' books, public art, installation, and performance. The resulting conversations were informal, providing a snapshot in time of the approaches of new media artists to their work. It was housed on Arts Wire's conferencing system and was an active forum until 1998. A record of its activities can be found at http://www.well.com/~couey/interactive. Sonya Rapoport participated in the Interactive Art Conference as a virtual artist-in-residence in June 1995.

02-JUN-95 14:03, Anna Couey
A Conversation with Sonya Rapoport

Judy and I are excited to welcome Sonya Rapoport to the Interactive conference this month! Sonya is a seminal San Francisco Bay Area artist who has utilized computers in her work since the mid-70s, often in an interactive installation environment. Her works are complex, humorous and playful. I first experienced Sonya's work in the mid-80s at Media, a now defunct artist's space in San Francisco. Her installation

ShoeField (see Plate 25 and Plate 26) involved the audience in taking off our shoes, entering shoe preference criteria data into a computer, and receiving a beautiful abstract printout of our "shoe field" that included a personality analysis based on our input.[3] Her most recent work, *Smell Your Destiny* (see Plate 29), is designed for the World Wide Web and is located at http://users.lmi.net/sonyarap/.

02-JUN-95 14:12, Anna Couey

Sonya has contributed a wonderful bio that describes the evolution of her work:

> During my computer-assisted art-producing years dating back to the mid-70s, metaphors and word associations have been the framework within which cross-cultures, diverse time periods, and multi-disciplines have comprised the content. Previously, I was rooted in contemporary visual arts, having been trained in the Hans Hofmann push-pull tradition at UC Berkeley. I was associated with the original John Bolles Art Gallery in San Francisco in the early 60s and my exhibition record included one-person museum exhibits at the California Palace of the Legion of Honor, the San Jose Museum of Art, and the Crocker Art Museum.
>
> In the early 70s, grasping for modes of expression in the exciting electronic world, I started by decoding scientific research printouts and drawing directly on the output.
>
> Since then, my work has employed digital tools with which I have addressed human concerns in an interactive installation environment.
>
> Current scientific issues of gene splicing and prescribed medication for personality change are subjects for my most recent art projects. *The Transgenic Bagel,* with sound by Craig Harris (see Plate 27), is a computer interactive work in which the participant gambles for a trait that is spliced from an animal. *Smell Your Destiny* (see Plate 29), an interactive Web project, answers our quest for success by prescribing aromatherapy. Both are humorous parodies and range in time from the Bible to the present, and both reveal the desire for individual control over behavior. These works will be exhibited respectively this coming fall at ISEA95 in Montreal and Digital Salon in New York.
>
> Earlier works were triggered by my own personal experiences. These experiences were repeated by participants with the use of a computer in an expanded conceptual format. Content such as analyzing a collection of objects, keeping a daily calendar, and wearing shoes was associated variously with American

Indian culture, palmistry, and Mudra gesture language. Franklin Furnace and the New School for Social Research in New York, 80 Langton Street in San Francisco, and the Peabody Museum at Harvard during the late 70s through 1988 were venues for solo presentations for these works.

Personal experience subject matter later gave way to universal anxieties. *Coping with Sexual Jealousy*, an audience participation event, was performed at the Pauley Ballroom, UC Berkeley, in 1984. Its interactive electronic adaptation, *Sexual Jealousy: The Shadow of Love* (with a musical score by Michael McNabb) was shown at ISEA93 in Minneapolis. *The Animated Soul* (see Chapter 1), adapted from *The Egyptian Book of the Dead*, confronts the subject of everlasting life. The viewer chooses paths to follow, both on the computer and in real time, amid an environment of caskets, pillows, and balloons. A casket warehouse, a private gallery, and the Kuopio Museum in Finland were sites for this installation in 1991–92.

02-JUN-95 14:13, Anna Couey

Welcome, Sonya! There are so many things to ask you about your work…but I'll try to restrain myself to start at more or less a beginning point—what was your first interactive work? How was it interactive, and how did interactivity relate to the content of the work? Did you know you wanted to produce an interactive piece when you started, or did the interactivity evolve from the making of the work?

02-JUN-95 15:12, Judy Malloy

Welcome, Sonya! It is wonderful to see you here and to get a chance to explore your seminal work in interactive installation in detail.

03-JUN-95 0:06, Sonya Rapoport

Hi, Anna and Judy: Thanks for the great introductions. I'm glad to be here and will try to answer all questions. Let's get started.

03-JUN-95 0:12, Sonya Rapoport

Objects on My Dresser (see Plates 7 to 24) was my first interactive piece. After having made art about "other" cultures and "other" artifacts, I proceeded to evaluate the random set of objects that had accumulated on my dresser for about 20 years. Their color, shape,

material, monetary value, and source were the attributes that I first concentrated on. Then, in 1979, I conceived a psychological analysis that focused on image-to-image and image-to-word associations as an art process. Psychiatric social worker Winifred De Vos and myself shared aesthetic and emotional responses about the objects and my connective associations. We looked at this material as an artwork and at the artist as a person.

Objects on My Dresser was produced as an audio/visual installation at the Franklin Furnace later that year, in 1980 at 80 Langton Street, and on KPFA's *Art Talk,* produced by Don Joyce and Jane Hall (see Plate 8). For the installations, the themes that had been derived in the psychologically oriented dialogue became the headings for six axes that bisected a 14-foot NETWEB plot on the floor. My associative connections between objects and themes were demonstrated by images of the objects that had been xeroxed and glued on 4 x 6-inch cards with easels. These were placed along the theme axes (see Plate 9).

A few months later in my studio, viewer/participants were invited to make their own projections by moving the cards from my original plot to another plot free of any image cards. This was the beginning of many different group viewer interactive participations.

Later on, Sonya

Sonya Rapoport
Shared Dynamics (from *Objects on My Dresser, Phase 3)*
Participant interaction in Rapoport's studio, placing cards on the radial axes.

03-JUN-95 17:50, Judy Malloy

Fascinating....So what led you to involve viewers as participants? It was certainly a radical idea for that time.

04-JUN-95 19:06, Sonya Rapoport

Judy: I'm trying to reconstruct what happened to trigger me into audience involvement. I think the answer is also pertinent to Anna's question of intent and awareness of making an interactive artwork. The dialogue between psychologist and myself contributed to the evolving form of the work; mainly, to its structure for interactivity. I originally had intended to enhance the art in some two-dimensional way through a deeper understanding of the objects; but the vitality in the exchange between us catalyzed further three-dimensional expression. Having resolved the visual execution of the piece, which I can discuss more fully later, the unmistakable excitement of discovery through verbal interaction caused me to extend this method of self-inquiry into use by others. Just as many discoveries just happen by chance, a few months after the Langton Street installation, a group (about 40) of my husband's chemistry graduate students and post-docs were coming over for Thanksgiving dinner. For their entertainment, I drew on my studio floor two NETWEBs, mine with my own associative distribution of card images placed along related theme axes; and the empty plot for them to fill. Very amenable and bright and interested in my artwork, the group viewed the configuration that reflected me, the artist, and were excited to reconstruct their own configuration. Winifred interviewed and taped each participant's response as to choice of image card and why the placement in the particular theme. The verbal inquiry heightened the sense of participation, intensified the vitality of the process, and provided documentation. So I added another phase to *Objects on My Dresser.*

05-JUN-95 0:01, Judy Malloy

Nice story, Sonya. Thanks. Can you tell us a little more about the objects that were on your dresser? What were they (or a few of them)? What kind of meanings did you and Winifred find that they revealed?

05-JUN-95 2:55, Anna Couey

Yes indeed—thanks, Sonya! It's wonderful to learn more about how you approached interactivity originally...how it grew from the communications element of the work itself. Did you see group interaction as a way to provide discovery for your viewers? Or to extend the scope of your examination? The first incarnation of the work was a self-portrait, right?—Did you still consider it portraiture once you began to work with groups? Did chance determine the group interaction was with an identifiable

group of scientists? Or did you choose this group to interact with the piece for a particular reason? Many questions, I know…and Judy's are good ones too. Feel free to answer at your own pace.…

06-JUN-95 23:18, Sonya Rapoport

There is much to relate, since we are scanning a project ongoing from 1979 through 1983. Before I get specific about the objects, Judy, I'd like to mention that I started creating the work while grieving for my mother, who had then recently died. Secondly, while enmeshed in experimenting with interaction to make the artwork, I was constantly concerned with how I would express visually each evolving stage. I never consciously thought I was doing interactivity per se, I just did it because the work called for it.

Yes, Anna, the NETWEB was *The 20th Century Portrait (Phase 6)*, advertised as a participation performance exhibition at Stephen Moore's Los Angeles Locus in 1982. We were hoping the viewing audience would commission portraits of themselves but no one did. However, *Phase 8*, a project for *Heresies* magazine, was more lucrative in that a resultant readjusted Sonya NETWEB depicted exclusively the objects and words revealing my relationship with my mother. The grieving period terminated. (See Plate 13.)

Now for the objects themselves. The dresser was a Tansu, on top was a batik. These I counted among the 29 objects which appear to me now as a very eccentric collection of stuff: a toy auto, plastic furniture cups to protect rugs, a satin pocket from a jacket, two slices from a conch shell, belly dancers' cymbals, a kinetic spool thread holder, crystal knobs, a half-inch round slice of wood, plastic foliage, tiny ceramic hearts, etc. After generating color-coded bar graphs of their attributes, I wanted something more probing. I assigned correlated images to each object and then assigned words to each of these, now 58, objects. Winnie and I recognized the words as well as the images "as clues to preeminent concerns. We looked for inner logic of elements that were repetitious. We speculatively played idiosyncratic symbolism against universal symbolism and we considered what was missing in representations apropos to a normative framework" (W. D.). SEE was the predominant reference among both the words and images. SEA related to the pattern on the batik and the shell slices; SEE-THROUGH, the response to the crystal knobs, the oval glass tray, and the furniture cups and the correlative object, a doll's glass eye. SEEING also surfaced for a photograph of a woman looking through an eye mask, even if a symbol of obscuration. Although this material was illustrated by imaginative x, y coordinate graphs, the words were obviously a tool for further communication, another link with the viewer (see Plate 18).

Judy, some of the meanings that evolved from the "play" with the SEE variations were: observation as a need to search, or comprehend; a way of dealing with developmental frustrations; artist as subject and object of mastery; herself seen as reflected by mirrors or by insight; a flexible reordering and a form of manipulating. Eventually EYE became one of the axis themes for the soon-to-be-created NETWEB.

07-JUN-95 12:04, Judy Malloy

Thanks, Sonya. It is nice to be talking with you. I saw the installation with the NETWEB on the floor at the old Langton St. and it was quite wonderful. Can you talk a little about what the NETWEB is/looks like? It is quite interesting that you chose that term (in 1980 or '81, I think this was).

09-JUN-95 2:22, Anna Couey

Yes, a prescient term for sure! It'd be interesting to see the NETWEB designed for the World Wide Web—because of its sensitivity to correspondences.

09-JUN-95 12:14, Beth Kanter—Arts Wire

Hi, Sonya—I've been looking forward to this discussion and like Valerie will be downloading and reading in the next few days.[4]

10-JUN-95 12:44, Sonya Rapoport

Valerie and Beth, I appreciate your interest in what seems to me a long story. However, because of a relevance to the conceptual configuration of the Internet's Web, I'm hanging in there.

Anna, I'll think about it as a Web project. Any suggestions out there about *how?*

Judy, here's a description of the installation you saw in 1980: Today's World Wide Web recalls the strategies of interconnections that I applied fifteen years ago when I created the NETWEB you saw at 80 Langton Street. Vance Martin was largely responsible for the dynamic presentation. It was a geometric configuration of a spiderweb about 14 feet in diameter, reflected onto the floor from a slide projector attached to the ceiling. Six bisecting axes, the tick marks on each axis and the linear connections from tick to tick were projected on a star-shaped area of white contact paper. The image cards, now reminding me of today's provocative home pages, were placed in their positions on numbered ticks along their selected theme axes: EYE, HAND, CHEST, MASKING, THREADING, and MOVING. I had made several duplicate cards because I wanted some associations to be in more than one theme. Everything was interconnected by lines crossing the axes and joining similar tick positions on other themes. The slide used in the projection was of the spiderweb graph that had been plotted on 30-inch-wide vellum. To generate this plot, numbers of the selected objects and their theme placement positions were punched onto cards and put into a now antiquated computer system. The installation included my dresser with all its objects, except the antique inch-round brass box that had been stolen from the Franklin Furnace exhibit; a plethora of xerox images of the objects documented with image-word vignettes; and graphs, data tools not used for fine

art expression at that time. Audiotapes of the dialogue between Winnie and myself played on a loop. I remember that people walked around and around, probably engaging in self-projections, evaluating their own mementos and what could be done with them. "The work elicited a sense of partaking of an artist's private world and a sense of that world's having aesthetic and effective parallels with the viewer's private world" (W.D.). I remember distinctly two comments: "What is a nice Jewish girl doing with Jesus Christ on her dresser?" The other, from a distant relative: "It's shocking that you say those things about your mother." Interactivity with the NETWEB was gaining momentum (see Plate 13).

10-JUN-95 21:42, Judy Malloy

Thanks, Sonya. I'm looking forward to reading this offline.

12-JUN-95 3:09, Anna Couey

Sonya, my first hazy thought about a Web iteration of this piece was to involve scripts so that viewers could make their own NETWEB and then read an analysis about it. Extending the social meaning that you brought to the NETWEB, by asking particular groups to interact with the work, the Web version could perhaps include a survey that would map responses to categories.

You've continued to make computer-based interactive work....How have your conceptions about interactivity evolved or changed? What role does interactivity play in your work now—is it a more conscious element?

12-JUN-95 15:25, Sonya Rapoport

Anna: I do want to talk about the different group responses and the different ways I installed the setup. It's a great idea to add another format of interactivity by listing possibilities for choices on the Web. Will think about it. Now, Anna, you have opened a can of worms regarding my current attitudes about interactivity, which I could go into after my last (next) description of interaction with *Objects on My Dresser*.

Later on, Sonya

12-JUN-95 21:13, Judy Malloy

Hi, Sonya. I loved the responses to *Objects* that you related and was interested in how the artists/lawyers/scientists differed in their responses (which sounds like what you might want to talk about at some point), but your current attitudes about interactivity that Anna asked about would also be very interesting.

12-JUN-95 21:18, Judy Malloy

And to add to the can of worms, I have come to feel that as interactive art comes of age as a medium, it is important, as in all art forms, that it be judged as art (not on how interactive it is or what kind of interactivity it uses, which is kind of like judging painting on how much paint is used, but rather on does it succeed as art).

12-JUN-95 23:14, Judy Malloy

I should add that I certainly think Sonya's work does succeed as art and that the interactivity is very much a part of her work.

13-JUN-95 9:28, Timothy Collins

Hi, Sonya....I remember your work at Media and am very much enjoying this topic! Looking forward to more ideas about interartivity!

13-JUN-95 10:38, Judy Malloy

interactgivity interartivity :-)

14-JUN-95 13:49, Sonya Rapoport

Tim, it's so good to hear that someone else saw my *ShoeField* installation at Media (see Plate 25 and Plate 26). One always wonders where our art ashes are scattered. Before going on to interactivity, I must get *Objects on My Dresser* off my chest. I did not set out to have specialized groups participate. However, we had captive science participants, between my husband's chemists from Berkeley and our son Robert's pharmacologists from Stanford; invitations came from art sites, among which were Sarah Lawrence College, New School for Social Research, and Artists Space, in New York, and Heller Gallery at UC Berkeley. For the participants the interviews proved to be the most challenging aspect to the participation—a complex activity of converting projections to the articulation of reason....why and what do the stimuli elicit? When I analyzed the results by plotting the NETWEBS, I noticed that the same interest groups' NETWEBS appeared similar to each other. To investigate further, I raided a neighbor's law firm party to persuade the hosts to allow their guests to come next door to my "laboratory" in order to participate in interactive art. They agreed. At first there was pushing and shoving among husbands and wives (both lawyers, I assumed) when placing the cards on the same theme axes. It was an intense, yet playful evening. I was a little disappointed that Winnie and I weren't invited for dessert when the attorneys were called back by their hosts. But I was grateful and ready to combine the specialized group data into three different NETWEBS, Art, Science, and Law. The

Art and Science webs were more alike than the sparse Law web. This meant that the attorneys made similar selections in placing the image cards on the same theme axes so there was less spreading of connective lines within the configuration. Most diversity of interconnections was amongst the art interest group, who generated an evenly distributed plot. The verbal responses were also distinctive. The science group responded to placement on the EYE theme by being challenged to fill in what cannot be seen. For the art group the EYE or seeing process was a means to thinking—a magical psychic entry rather than surface observing. The law group conveyed a self-consciousness in looking. They indicated a heightened sense of visual process, of carefulness and alertness. Thus the artwork had evolved into group characterization of commonality of interest class through graphic configuration (see Chapter 3).

Now, we are all eager to squirm with that can of worms (words) that Anna opened. Judy, we'll see if we are killing or nourishing the artamphibia when we cut them into interactgivity, interartivity, and reactivity for bait.

15-JUN-95 11:43, Judy Malloy

Thanks, Sonya! I was in the same show at Heller, I think, and I remember that you tape-recorded some of the responses and then a little later the NETWEB showed up in that gallery that Terry Ellis and David (can't remember his last name, but he was such a nice guy and died of AIDS, as did Terry) had. It was a window gallery and the web was in the window and I think from the street you could push a button and hear some of the previously recorded responses.

15-JUN-95 11:45, Judy Malloy

David Mott (is that right?). It would be good to get some scanned images of the NETWEB that we could attach to this conversation when it goes on the Interactive home page.

17-JUN-95 21:01, Sonya Rapoport

Judy, thanks for boomeranging me to the NETWEB, because I'd like to talk about a few site-specific formats, especially Terry Ellis's Window. Terry eventually moved to New York and made his mark as a promising artist before he died. In my Egyptian ritual *Animated Soul* installation at the Takada Gallery I hung Terry's portrait over a mummy's mask. This was my way of saying good-bye to him. Among other NETWEB interactive formats was a presentation in the *Journal*, the Los Angeles Institute of Contemporary Art magazine publication. Readers were to check a list and mail it to me in return for a plot. The window of a Philadelphia storefront, donated by a bank/neighbor, consisted of irregularly angled glass panes. Webs from various interactions serpentined along the glass. But the setup on the floor was sparse because

bank employees couldn't stand my pornographic and violent images and had them removed. The installation at Terry Ellis's and David Mott's Window was a different story. Its data had come from the Heller Gallery (UC) performance, where your piece was nearby, Judy. There I recorded the responses that eventually blasted on the street from a loudspeaker that was installed outside. Pedestrians passing by could push a button to hear the "why" of *Object* choice-placements such as: "I placed it (a sea creature) on HAND because I wouldn't want to touch it"; "I placed the snake on EYE because I wouldn't want it to get near my hand"; "I placed an EYE (big bosoms) image in front of HAND because you can't kiss and breathe at the same time"; "I put the screw on MOVING because you move when you screw." Illustrating the sound track, these images and their corresponding theme axes were glued to the large window (16 feet wide). In the smaller window, a six-foot photograph of the dresser hung as background for the object images stacked in rows on the floor. Cards and pencils were available for responses to be dropped into the mail slot (see Plate 10).

During the process of recycling the objects back to nature by associating them with visual information in James Randklev's Sierra Club photographs, Winnie and I had our last interactive *Objects on My Dresser* exchange. In 1983 Humboldt State University was last host for the audience participation installation (see Plate 16).

20-JUN-95 3:31, Anna Couey

Objects on My Dresser certainly had many permutations that seem opened up largely because of the interactivity you brought into the piece and then investigated. It is rich fabric you have woven there!

Judy…your statement that interactive art needs to be judged on how it succeeds as art is a provocative one. I can perhaps guess, but what do you mean? In conveying meaning rather than technique? And Sonya, whenever you're ready to dive into that current-views-of-interactivity question, please do! I've been fascinated by everything you posted so won't be distraught if there's another direction you'd like to head! Was interested to read about the installations….Did you make installations prior to working with computer-assisted art?

21-JUN-95 11:17, Judy Malloy

And thanks, Sonya, for giving us so much of your time!

21-JUN-95 17:51, Sonya Rapoport

I am very busy scanning photographs of *Objects on My Dresser* so that readers will be able to view some of the scenarios we have discussed. However, Anna, I can't resist getting into the "interactive" discussion by evaluating interactivity as art in *Objects on My Dresser*. There is no doubt that interactivity motivated the excitement and

interest in the piece. Here we go, Judy: would the discussions between Winnie and me or the participants' activity of making choices and placing their projections on the plot stand alone as art? The verbal interchange added another dimension for further aesthetic formats; and although some musical duets or literary exchanges in scripts can be considered art, I think that the interaction between Winnie and myself is taking deconstructive theory a little too far. The application of the participants' contributions changed the graphic art configuration of the NETWEB. This influence upon the artwork itself is the highest form of interactive art. Whether the results are a high art is another story. However, the interactivity did transcend into art concept and maybe that's what we are talking about.

23-JUN-95 3:06, Judy Malloy

Well it was that "highest" yardstick that I was questioning. And actually I do think there is some validity to Steve Wilson's idea that work is most interactive that integrates the participants' responses into the work as you did. I think this is definitely something to strive for. But—yeah—you could have framed your conversations with Winnie in some other way and that could have been art also. But what I meant was, for instance, in your webwork the interaction is much "lower." Does that mean it has less validity as interactive art? Does that matter?

25-JUN-95 15:10, Sonya Rapoport

Yes, Judy, the three different levels of interactivity in art are:

1. The viewer completes the work by perceiving it;

2. The viewer interacts with computer programs from a predetermined set of options;

3. The viewer's choices alter the final form of the artwork.[5]

My webwork *Smell Your Destiny* utilizes the above second level of interactivity. Here, according to www protocol, the viewer clicks on a highlighted phrase or icon to access the next link. This is a newer feature in the second level of interactivity. I do not think level 2 is less valid as interactive art. Although interactivity plays a major role in executing my piece, the implication of using both words ("interactive" and "art") as a phrase can be that the art is on one level and the interactivity operates on another. I like to think of *Smell Your Destiny* as an integrated artwork and the interactivity is a device for supporting its ideas and for getting the viewer personally involved in them. "Interactivity" has become a buzzword. Any excuse is used to get into the act. What is interactivity by itself? Is it interactivity or just reactivity when a response is generated by a sound, a movement, or a pressed button, and no further interchange results?

Interactivity has come of age as a medium, just as oil paint did. Innovation of the former depends on the technical sophistication of the creator, just as skill depended on the technique of the latter. Currently, if the end product purports to be interactive

art, development of the art is required as well. A combination of technical and art skills is necessary. We may anticipate that the results will be so innovative that at first we won't recognize it. Two examples of innovative interactive interface are on exhibition in San Francisco this month of June. Jim Campbell and Marie Navarre's *Unforseeable Memories* installation is at Capp Street, where changes in the room occur from immediate viewer movement to more subtle activity over a two-month period. For example, projected images will dissolve and others will go from one location to another. The technology here is rather arcane and it is hard to tell what and how changes are triggered. Bruce Cannon's *Portrait* at the Paule Anglim gallery consists of two objects: a wooden box, the control unit, that will remain in the artist's studio; and a sculpture of a scale, which will reside with the owner. These two devices are linked by telephone. The artist recodes the control unit monthly. The balance beam at the owner's home moves one degree per year of the artist's life. Whether the art in the Campbell/Navarre installation is as highly developed as the technology is yet to be absorbed. Bruce Cannon's *Portrait* has achieved an even balance.

27-JUN-95 2:27, Judy Malloy

Well, Sonya, you've got me thinking (and enjoying it!).

28-JUN-95 1:21, Sonya Rapoport

Well, Judy, what are you thinking?

29-JUN-95 13:17, Judy Malloy

Bruce Cannon's *Portrait* sounds like a really interesting idea—a kind of connection, which interests me, since I like to think of interactivity as a way of connecting the artist and the viewer. And ideally, the interactivity and the art are seamlessly integrated, which is what I think you are saying. This conversation has been stimulating and the many unfollowed threads we could still follow are indicative of how much interactive art has developed in 15 years or so since you began to work on *Objects on My Dresser*. Thanks again for sharing your work and ideas with us! I can think of many more questions, answers, information, but we only have a day left. Sonya says if anyone has further questions, they are welcome to email her at sonyarap@lmi.net.

30-JUN-95 19:28, Sonya Rapoport

It has been a great experience digging into my interactive roots and sharing them with you. Anna and Judy, many thanks to you and others responsible for this opportunity; and thanks to those who said "hello"—Valerie, Beth, and Timothy; and to those who said "hello" by reading.

'Bye, Sonya

02-JUL-95 16:25, Anna Couey

Many thanks for your participation, Sonya! It's been wonderful to learn more about your work and how you've approached interactivity.

Notes

1. Originally used by Joseph Beuys, the term "social sculpture" was used in this context to describe art that operated in social space. While drawing on a broad history of artistic experimentation engaged outside gallery walls, including crossover art movements in the 1970s and 1980s such as television art, social sculpture was adopted to provide a framework for work that sought to shape social systems as an artistic practice. During the 1980s and 1990s, several artists and artists' organizations created telecommunications systems by designating online spaces, and shaping network policies and practices. "Social sculpture" served as a descriptor in the absence of a commonly shared term for this work.

2. "Art telecommunications" is the term used in several seminal sources: *Art Telecommunication,* edited by Heidi Grundmann and published by Western Front (Vancouver, Canada) and Blix (Wien, Austria) in 1984; and "Connectivity: Art and Interactive Telecommunications," in *Leonardo* 24, no. 2 (1991), edited by Roy Ascott and Carl Eugene Loeffler, describing artists' work with telecommunications technologies in the 1980s and 1990s, including slow-scan television, fax, email, computer bulletin boards, and conferencing systems. Decentralized, participatory, and collaborative, such work emphasized communications exchange. "Net art," "art.net," or "network art" today describe art made with contemporary telecommunications systems, particularly the Internet, however are not as inherently process-focused as art telecommunications.

3. The following text replicates, to the extent possible, the format of the original conversation. One exception is the titles of artworks, which for the sake of consistency follow the form used throughout the book. Typical of the time, the conferencing software used for the conversation allowed only such formatting as could be typed with a keyboard; font selections, italics, and bold type were not possible, and participants created their own standards to distinguish titles within the text.

4. Valerie posted a comment in the original conversation. We were unable to locate her to obtain permission to republish her words in this publication, and have therefore removed them from this version of the text.

5. The discussion of levels of interactivity in art reflects the importance of ideas about interactivity at the time, and there are multiple sources for definitions of interactivity in art and of different levels of interactivity in art. Steve Wilson describes multiple levels of interactivity in his paper "The Aesthetics and Practice of Designing Interactive Computer Events" (http://userwww.sfsu.edu/~swilson/papers/interactive2.html), based on a SIGGRAPH conference paper he wrote in 1993. In her review of *ShoeField* in *ArtWeek* (October 25, 1986), Christine Tamblyn stated three different levels of interactivity that can operate in art: The most basic level of interactivity is perceptual and stems from Marcel Duchamp....The viewer completes the work by perceiving it; 2nd level, the viewer interacts with computer programs from a pre-established set of options....The 3rd level allows viewer's choices to alter final form. Robert Edgar wrote a series of articles on the nature of interactivity that include a variety of measures—see "Interactivity Part 2," first published in Art Papers 10, no. 2 (March/April 1986) and available at http://www.robertedgar.com/Articles/Interactivity%20Part%202.pdf. Very likely there are additional sources.

Sonya Rapoport: On Drawing and Data

John Zarobell

In October 1978, Stephen Moore, the director of the Union Art Gallery at San Jose State University, devoted an exhibition to the drawings of Sonya Rapoport. In his introduction to the show, Moore admitted, "While 'drawings' is certainly an accurate term for this work, it is at the same time perhaps misleading, for Sonya's art is overwhelming in a sense that few drawings are, both in terms of scale and content."[1] The works that were shown in that presentation, including works from the *Anasazi* and *Mixed Media* series, were generated on computer data printouts and the artist had traced forms and letters on these sheets in colored pencil and graphite, creating a graphic conversation in multiple layers of image and text. The exhibition title, *An Aesthetic Response*, was derived from the artist's statement:

> My work is an aesthetic response triggered by scientific data.
> The format is computer printout, a ritualistic symbol of our
> technological society. My concerns deal basically with reflecting
> the society in which I live and clarifying the scientific approach
> to the understanding of this reality.[2]

Leaving aside the enormity of Rapoport's ambition to clarify the scientific approach to understanding reality, the question of the artist's "aesthetic response" begs examination. What is aesthetic about her response to scientific data? How can one come to terms with the aesthetics of scientific data? These are not the kinds of questions most artists ask themselves, and the elucidation of her aesthetic response will explain a lot about what is unique and significant about Rapoport's artistic practice and what her drawings mean to us.

The notion of drawing inheres an idea that the artist is expressing something, working from the inside out, but drawing is an engagement of the faculties to produce a picture of the world, whatever may constitute that world. One can draw a figure, a

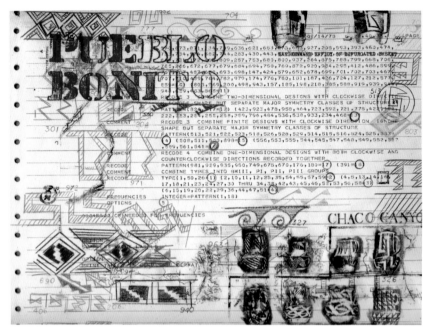

Sonya Rapoport
Bonito Rapoport Shoes (detail), 1977
Transfer print and colored pencil on continuous computer forms, 110" H x 15" W

place, a view, or an idea, but the fundamental requirement of drawing is to connect the mind of the artist to something outside of it and result in a pictorial representation. In this case, the world outside is the data produced through scientific experiments, sometimes graphically rendered in computer printouts but usually indecipherable to those outside of the field of inquiry. Rapoport, who was married to a noted chemist at the University of California, Berkeley, was unique in viewing data charts as aesthetic objects to engage with artistically. To her mind, printouts contained information presented in a manner that was visually compelling and "triggered an aesthetic response." In other words, the design of the computer output on the standardized sheets (fifteen inches across) was a means of organizing data rendered through an experiment that represented an entirely new visual language, akin to modern hieroglyphics. Rapoport's experiment was to consider the possibilities for engaging this data as an artist. As Moore put it in 1978, "By developing her own visual language system within a scientific format, Sonya Rapoport fuses traditional concerns of the artist with contemporary involvement with information and language structure, producing a synthesis of aesthetics and technology which I believe presents us with a clear view of the future."[3]

This method of inquiry was something that the artist discovered almost

by accident. In 1970, Rapoport discovered a series of geological survey charts in an antique desk she purchased. She has written, "The survey charts coalesced my attraction for the visual geometry of scientific data, and my interest in quantifying qualitative information."[4] The idea of using found material to enrich works of art had a long history by that point. In 1961, William Seitz organized the exhibition *The Art of Assemblage* at the Museum of Modern Art, where Robert Rauschenberg's early works were shown alongside works by classic modernists such as Hans Arp and Kurt Schwitters. The show traveled to San Francisco. This exhibition of three-dimensional collages made out of a variety of found materials generated an interaction between the detritus of contemporary life and the productive work of the artist. Though the artists featured in this exhibition were elaborating the long-standing modernist tradition of collage, assemblage was distinct in that it employed recycled material for the implications and metaphors it possessed. Rather than claiming a form of originality in their artistic process, artists embraced the contingent originality of the bricoleur, the figure who collects scraps and assembles them into newfangled structures. This means of engaging the world—collecting junk and finding a use for it—was juxtaposed to the self-consciousness and self-importance of the New York School painters of the 1960s. Embracing junk, for then contemporary artists such as Rauschenberg and Bruce Conner, meant rejecting the aesthetic criteria of the previous generation but it also was a means of renewing the tarnished goal of the avant-garde, to connect art and life.

It is interesting to note that Rapoport came across these survey charts to draw on at the same time she was engaging in her own collecting practice directed towards artistic ends. Her *Pandora's Box* (see Plate 1) was an old cigar box where she kept a variety of objects and stencils that allowed her to generate imagery through tracing. These found objects were not, as in assemblage, employed in her actual works but they were a means of generating repeatable imagery that held a particular significance to the artist and were in many cases connected to her experiences as a mother during these years. In one diagram, the artist spells out the meaning of many of these symbols. There are fetus-like images derived from a fleur-de-lis, a uterus from a toy anatomy set which, when superimposed on itself, generates an X, which Rapoport associates with the extra female chromosome, and other objects that produce more decorative than symbolic patterns. The discovery of the survey charts provided the artist with a background on which to trace the outlines of her significant personal objects. It was an opportunity to play out the imagery of personal life into another domain, namely the scientific measurement of the landscape in the case of the survey charts.

From *Survey Chart #15* (1972; see Plate 2), it is possible to see how Rapoport began using these charts with the stencils from her *Pandora's Box*. In the center at the bottom of the sheet is a colored square surrounded by three tracings of the uterus stencil in black and yellow, and an array of colorful forms spreads across the survey chart, leaving certain elements of the chart completely clear, such as the label in the lower right and the list of drawings on the lower left. The pictorial imagery is here added to the top of the survey chart but in such a way that elements of the chart

continue to be legible. The text explaining the chart here competes with the color-ful shapes and forms derived from the artist's stencil set. While this model brings together picture making and information rendering on a single plane, the result is highly decorative, despite the specificity of some of the stencils Rapoport used. One explanation of this visual art practice is to say that the artist has effaced the original scientific study in order to produce an image that operates on a different register. This is certainly true here, since the eloquent abstract composition trumps the presenta-tion of data, but it is not clear that art vanquishes science in this picture. The fact that the texts are not covered suggests that the artist wants us to read the original text and seek to compare it to what we see in order to make meaning out of this abstract pic-ture. This is a fundamentally intertextual production. The text of the chart competes with the personal meanings of the stencils and the elaboration of the image through colorful forms. In such a schema, there is no clear subversion of one of these texts in favor of the other; they simply coexist. It is fair to say, though, that at this point in her career, Rapoport continues to be interested in picture making as the fundamental nature of her practice. In the *Survey Charts,* she is an abstract artist picking up found objects and using their formal characteristics and the meanings lodged in those to elaborate further the implications of her pictorial investigations.

While such a model challenged the aesthetic autonomy of abstract art implic-itly, her next group of mixed-media works (the *Mixed Media* series) would explicitly engage in the production of meaning through language. In this series, Rapoport also used found material to draw on, computer printouts which she cribbed from a dump-ster near the computer science department on the UC Berkeley campus. Though she produced a large number of these works between 1974 and 1977, the focus here will be on what change in her artistic practice emerged in these works and how they led to a more interactive model of research and a means of working beyond the limitations of a single length of paper.

One of the major innovations here was joining multiple sheets by sewing them together with thick colored thread, allowing for an expansion of the pictorial plane. In *Charlie Simonds* (1976), the artist sewed together four sheets of computer printouts and employed the entire surface to generate an expansive composition including a number of motifs. The work's title refers to the artist Charles Simonds (American, born 1945), whose miniature clay buildings Rapoport encountered at the Museum of Modern Art. In this piece, the artist once again draws with stencils from her *Pan-dora's Box*, tracing and coloring in forms, but the subject of the drawing (the work of Charles Simonds and the associations it engendered for Rapoport) is the path that leads the viewer to a specific destination in these works.

Simonds is one of a number of significant figures that Rapoport treated in this series, which included works dedicated to Pablo Casals and John Graham, among others. The new twist of these works is that they record a personal experience of the artist (there are also works titled *French Dinner* and *Malaysian Wedding)* and translate that interaction in visual terms across a surface of sewn-together computer printouts. In the case of *Charlie Simonds,* the experience is Rapoport's discovery of a body of

Sonya Rapoport
Charlie Simonds (detail), 1976
Transfer print and colored pencil on continuous computer forms, 60" H x 77" W
77 x 60 inches

Charles Simonds
People Who Live in a Circle. They Excavate Their Past and Rebuild It into Their Present. Their Dwelling Functions as a Personal and Cosmological Clock, Seasonal, Harmonic, Obsessive, 1972, Clay with sticks and stones, 8 3/8 x 26 1/4 x 26 1/8 inches (22.2 x 66.7 x 66.4 cm)
Kay Sage Tanguy Fund
© Charles Simonds/Artists Rights Society (ARS), New York. Digital image © The Museum of Modern Art/Licensed by SCALA/Art Resource, NY.

artwork that paralleled her own interests on many levels. Simonds created miniature dwellings and cities modeled on Anasazi architecture, originally created between 700 and 1300 CE in the southwestern United States, and placed these structures sometimes on pedestals in museums, as in the Museum of Modern Art's work *People Who Live in a Circle. They Excavate Their Past and Rebuild It into Their Present. Their Dwelling Functions as a Personal and Cosmological Clock. Seasonal, Harmonic, Obsessive* (1972). In other works, Simonds placed his structures in the midst of the city. All these works by Simonds address the fundamental nature of human dwellings, such as shelter, environment, and history, but finding such finely crafted miniature clay structures in the midst of the modern city is intended to force a reconsideration of one's place in the world, and indeed the universe. Rapoport was fascinated by the artist's ability to evoke universal and timeless subjects, and she set out to explore the significance of his work in her own mixed mediums.

The four sheets sewn together are the structure of the work, its foundation, but here already one finds a blending of languages both personal and impersonal, coded feminine and masculine. The act of sewing together computer printouts with colored thread is radical in itself, a kind of feminist reappropriation of the stuff of hard science. The effect is to transform immediately the ground for the drawing, suggesting an intersection of the domains of knowledge and immediate practical experience. It is not only that Rapoport was the first artist to engage in drawing on data printouts. The real innovation of these works is to appropriate scientific data for a personal expression of the artist, one which incorporates a variety of interlocking symbols and forms of signification in order to produce its meaning. This multilayered character of constructing meaning in the work is emblematized by the artist's choice to construct her work out of someone else's data refuse. In the *Mixed Media* series, Rapoport takes the assemblage idea to the next level, assembling not only a variety of objects and symbols but the very language of information as it is produced through a computer science experiment.

The drawing itself is a blend of stencil drawing, crossing out data with a variety of miniature colorful forms to create a broader pictorial pattern, graphic writing ("YOU BROUGHT ME BACK TO EARTH" is stenciled in graphite), and a copied motif of a canal from one of the topographical maps included on one of the survey charts. The curving form of the repeated lines representing the canal echoes the form of Simonds's clay structure that Rapoport encountered at MoMA, but also suggests, when paired with stencils signifying female sexual organs, the birth canal, which is the source of all life but is possessed only by women. This discovery of Simonds's art that brings the artist to a recognition of her identification with the earth and the particular power of her gender is the subject of this work. But this message is embedded in an arcane language of forms and references artfully composed across the surface of a data set.

In another work from a different series that references Simonds, the structure of symbols and language is simplified. In *Charlie Simonds, Microcosm/Macrocosm* (1976; see Plate 3), Rapoport develops another visual language and employs it in a

single-panel printout series comprised of letters traced with color pencil and graphite from an alphabet stencil to duplicate the "found" information about the subject. On some pieces, like this one, the original articles and their images were machine copied and then collaged onto the printouts. The duplication of the material would make a challenge for the viewer to follow the "decorative" transcription with the original text. This work is inscribed with the title of an article published in *Artforum* in February of 1974. The article, "Microcosm to Macrocosm/Fantasy World to Real World," is the transcription of an interview Simonds gave to Lucy Lippard and spells out the aims of his artistic language and the structures that he built, originally in the street, for the "little people."[5] Simonds's rhetorical tack is playful while his art is seriously engaged with breaking down the boundaries between art and the life of the streets where he built his works. By reaching beyond the scope of the art world and making ephemeral dwellings in the streets, which are encountered by passersby, Simonds engaged with notions around Earth Art that had emerged in the late 1960s. He further articulated a fantasy life which his work makes collective through viewer imagination and participation.

Rapoport's work similarly seeks to link microcosm to macrocosm. By working on scientific data, she hopes to connect the world of science to the world of art. She forged her own language of colored shapes that appear as abstract and meaningless as the rows of numbers on the data printout. She is playing here not with clay but with visual language and the interpretation of it. While we see patterns take shape across a very long drawing, sometimes covering the columns of numbers and sometimes leaving them exposed, we encounter two languages—of art and computer science— usually considered mutually exclusive. Rapoport pairs them, not merely to juxtapose their differences, but also to comprehend their similarities. Like computer science, the art world is full of codes and references that sustain one another and create a network that allows a work of art (like a program) to function. Here she breaks down art making to a series of interlocking pictorial signs, not unlike the brushstrokes of her early paintings. The difference is that we do not associate these signs with freedom, or originality, but with a kind of structure. This is partially because they follow and trace the linear dynamic of the printout and also because the colored shapes repeat, allowing for new combinations to be generated out of the flow of forms. While neither the scientific language nor the artist's personal symbol language are known to me, I do know that the final image is a result of signification, making meaning that results in an overall effect the work expresses. We comprehend the relationship not only of art to science, but of the individual to the collective and the importance of communicating in a language that others can comprehend.

In this sense, it is significant that Rapoport next moved into working on computer printouts whose meanings she often fully comprehended. The works in the *Anasazi* series are drawn from data derived by a scientist with whom the artist collaborated and whose results were fully known to her. Rapoport began working with anthropologist Dorothy Washburn, who was analyzing patterns on sherds of Anasazi pottery in order to determine stylistic similarities and distinctions that might inform

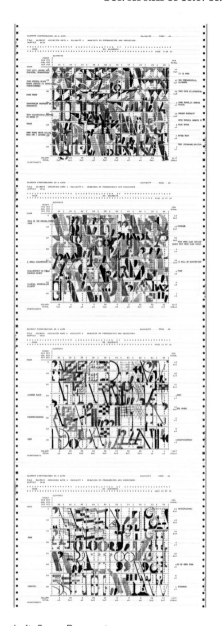

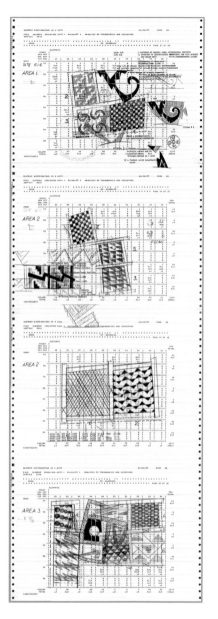

Left: Sonya Rapoport
Anasazi Series Panel II: Language, 1977
Transfer print and colored pencil on continuous computer forms, typewriter text
110" H x 15" W

Right: Sonya Rapoport
Anasazi Series Panel II: Patterns, 1977
Transfer print and colored pencil on continuous computer forms, typewriter text
110" H x 15" W

a broader understanding of the development of material culture among this now-extinct cultural group. Washburn's research was based on an analysis of a number of specific data points, such as number of rows, direction of arrows, etc., on potsherds collected in a variety of areas, and the printouts present the information she collected in a graphic manner. In her earliest works in this vein, such as *Anasazi Series Panel II,* 1977, Rapoport juxtaposed patterns from the potsherds on grids of data. The way she lined up the marks on the sheets suggested a direct correlation between the graph, representing the visual presentation of data in contemporary sciences, and the patterns, which would have been a form of communication among the Anasazi. In later works, Rapoport mixed the languages of image and text and referenced Washburn's data in multiple pictorial languages.

In the case of *Pueblo Bonito* (1977), Rapoport generated a complex palimpsest of image and text on the introduction to Washburn's data printout. Here, the words "Pueblo Bonito" are made from stencils with red pencil, and various fragments of patterns from the potsherds themselves are traced in different colored pencils, each numbered as the objects of Washburn's research must have been. Pueblo Bonito was the largest Anasazi settlement, located in Chaco Canyon. Though most of Washburn's sherds came from elsewhere, in this work the artist focused upon those from Pueblo Bonito. Some of the numbers listed on the printout here are circled with various colored pencils, leading the viewer to believe that the patterns in certain colors correspond to the circled numbers. There are also images of Anasazi pottery, complete vases and jugs that have been transferred to the printous by coating the backs of copies with acetone and rubbing the images through onto the printout. Each of these pots includes a number of different designs, and the blurriness that results from the transfer makes it seem that these images are floating on the page. Finally, in a gesture that hearkens back to her work with the survey maps, Rapoport has also transferred segments of topographical maps of Chaco Canyon, again rubbing on select details with the use of acetone to generate a map.

In this work, one can detect a movement towards an interactive framework between image and data, as the artist developed an image response ("An Aesthetic Response," as her exhibition at San Jose State University was called) to visual presentation of statistical material. The difference here is that she is using the data to generate the image and to encode further superimposed related images, rather than using stencils, which manifest previously formed images. On one hand, the viewer perceives the abstract patterns from the pottery and the numerical data that corresponds to them. On the other hand, transfer rubbings render figurative illustrations of the objects under investigation. Rapoport's works from this series were first shown at the Peabody Museum of Anthropology at Harvard University in May of 1978, but they were then shown at the Truman Gallery in New York in January of 1979, demonstrating the interdisciplinary interest in her artistic work. In the announcement for the Truman show, called *Interaction: Art and Science* Washburn wrote:

> It [collaboration with Rapoport] has shown me that the act of combining parts to make a whole lies at the heart of the creative process and therefore that codifying this process in symmetry

classes [what her research accomplishes] is a valid, meaningful classificatory procedure. Basic aspects of arrangement of forms in space and colors with forms, for example, appear to be handled in a similar ways whether it be an ancestor statue carved by a primitive artist in 2000 BC or on a large canvas by an abstract expressionist in AD 1978.[6]

Beyond her recognition that Rapoport's artistic process substantiates the aim of her research, Washburn's statement is useful because it points to the timeless character of Rapoport's artistic process of connecting information gleaned from the environment and organizing it into a legible pictorial structure.

Another work that emerged from her collaboration with Washburn is *Bonito Rapoport Shoes* (see Plate 6), which references the discovery of a foot effigy amongst the Anasazi that was made by a Mesoamerican culture residing one thousand miles to the south, thereby proving the existence of extensive trade routes in North America ca. 1000 CE. This image is juxtaposed with a text printout describing the data outcomes, but other panels of the work juxtapose sandal-weaving patterns with potsherd patterns over graphic data output as well as regional maps of Anasazi settlements. In both pictorial style and technique, this work shares a lot with the *Cobalt* series (see Plate 4), a collaboration with a nuclear scientist that occupied Rapoport at about the same time. The blending of copied pictures, writing, language, and statistical data would become the hallmark of Rapoport's subsequent style, whether executed on paper or on the Internet, in HTML format, but the foot effigy became a point of departure that would launch another domain of artistic practice, the *ShoeField* series, in which the artist would make the viewer an active participant.

Before discussing Rapoport's work in the 1980s, it will be valuable to consider her work in the wider context of the evolution of the visual arts that came to be institutionalized around 1970. The exhibition entitled *Information*, organized by Kynaston McShine at the Museum of Modern Art in 1970, sought to take stock of a variety of artistic practices that had emerged worldwide in the wake of Minimal art. In her 1973 book *Information*,[7] Lucy Lippard termed this development "the dematerialization of the art object" and it is perhaps a telling sign that Lippard herself was included as a participant in this exhibition despite the fact that she is known as a critic. *Live in Your Head: When Attitudes Become Form* followed on the heels of another exhibition, organized in 1969 by Harald Szeemann at the Kunsthalle Bern, *NETWEB*. In his English-language introduction, Scott Burton wrote, "Categories are being eradicated, distinctions blurred to an enormous degree today....The tremendous critical intelligence demanded from the ambitious artist is bringing him closer and closer to the intellectual; art and ideas are becoming indistinguishable."[8]

The presentation of these two exhibitions in Europe and the US in subsequent years demonstrates an evolution in art institutions to accept and attempt to represent works of art that are ephemeral, transitory, and do not conform to the categories of painting or sculpture. A relevant example of a participatory interactive work would be Hans Haacke's *MoMA-Poll* (1970; see Introduction). Haacke is seen as a systems artist

and his work explores and exposes the systems that govern collective life. *MoMA-Poll* required the viewer of the artwork to become a participant who collaborated to produce the piece. On view were two Plexiglas cases, each functioning as a voting box where ballots were placed. On the wall of the gallery, the artist placed this text:

> *Question:*
>
> *Would the fact that Governor Rockefeller has not denounced President Nixon's Indochina policy be a reason for you not to vote for him in November?*
>
> *Answer:*
>
> *If 'yes'*
>
> *please cast your ballot into the left box*
>
> *if 'no'*
>
> *into the right box.*

As is evident from the image, the work "produces" a collective decision, demonstrating the results of the poll, which are visible to all. The work of art in this case is not the boxes, or the type on the wall, but the series of interactions between the artist, the institution, the viewer/participant, and the national/international politics that are at issue in the poll. *MoMA-Poll* is one of the most oft-cited works produced for *Information* perhaps because its systematic innovations on the work of art were one of the most effective manifestations of the exhibition's goals. When Rapoport sought to expand her intertextual drawings beyond the page and devised a system to produce a drawing from data, she followed Haacke's example of a dematerialized, interactive model of artistic production for her next foray into "intermedia."

Rapoport staged her first interactive work, a *Shoe-In* at Berkeley Computer Systems in June 1982. The choice of the location tells us a lot about the nature of the work she was engaged in at this time. This was the moment when technology companies began marketing personal computers, and this store was one of the very few devoted to selling home computers in Berkeley. The novelty of these products, and the fact that they were predominantly used by scientists before this, meant that the interactive artwork Rapoport produced was another effort to cross the boundaries between art and science. A later, related performance would be held at Media, a gallery in San Francisco, but it all began in a computer store.

Inspired originally by the history of the foot effigy that turned up in her anthropological project, Rapoport had been considering her own shoes and what kind of history these products might tell. During the NETWEB she engaged the public to answer questions about their own shoes. As she explained in an article from 1983, "Each participant's involvement was three-fold. First their shoes were photographed,

Sonya Rapoport
ShoeField Map, Sonya Unfolding (detail), 1982–85
Transfer print collage and colored pencil on continuous computer forms

next they answered questions to a computer and lastly they were interviewed about their shoes."[9] Participants were asked to select a footrest for their shoes to be photographed on. The participants were all given a number upon entry and, from the questions they answered on the computer combined with their choice of footrest and their leg/shoe position in the photograph, a second number, or a "charge value" (-2 to +2), was assigned that indicated how they felt about their shoes. The entry number and the charge value were computed into an electric field theory program to generate a force-field map, which the artist described as "a topography-like output printed on continuous computer forms."[10]

The resulting work, titled *ShoeField Map* (1982–85), is a fascinating artistic work, a hybrid drawing made from human interactions with machines, generated by a computer program. The seventy-six participants are rendered on the sheet in rows of five across, in the order that they entered, and the interaction of their relative charge values determines the sequence and patterns of letters that render each participant's shoe psychology. In a detail of the work it is possible to pick out individuals by the presence of a tilde (~) at the center of each pattern configuration. Surrounding this sign is a group of letters representing the individual's shoe charge but, as one moves

from center to periphery, the field theory takes over and the interactions between charges generate unforeseen patterns, leading to an overall decorative motif. When a viewer looks at the complete work, waves and forms emerge, patterns formulated from the repetition of typewritten symbols that provide a sense of a broad structure composed of multiple elements. Indeed, the entire composition is formulated from letters and various other signs from the keyboard but it is also possible to see the various nodal points as circles and the forms of interactions the program charts between them. The artist chose to call this work a "map" and she employed the word "topography" to describe it, harking back to her use of topographical survey charts. But if maps are the systematic transcription of landscape details, what is being described in this map? Even more pressing perhaps is the question, How is it being described?

Rapoport's use of technology should not blind us to the fact that she is working out a structure of human interactions, even if they are based on their relationships with inanimate objects, their shoes. What the map features is a group of responses which are fed into a program that is designed to produce a field. This field is abstract but the interaction of humans with machine that led to it is not. What is compelling is that the map itself is abstract yet based on a code, so therefore it can be decoded, read for its meaning. Almost thirty years later how these unnamed people felt about their shoes seems meaningless but the device Rapoport concocted for rendering their relative responses seems absolutely compelling. Not only do we have a systems-based interactive artwork, following the line of thought elaborated by Haacke and others, but the interaction here is between humans and machines and adumbrates a particular moment in the history of humans' relationship to technology. The question is less "How did they feel about their shoes" than "How could those feelings be quantified and charted through a technological mechanism." As such, this work represents an evolution of human interaction and experience.

More compelling still is the map itself, which sets out a new domain in the realm of artistic production. If drawing is an engagement of the faculties to produce a picture of the world, connecting to the world, this is a drawing that not only represents an ineffable subject but also an ineffable means of interacting with the world through technology. An artist records information but, in this case, that information is computed as data and rendered mechanically. What is more, Rapoport asks her participants about their feelings, their conscious or subconscious relationships to their footwear, and so she is engaged, like the Surrealists before her, in making the invisible visible. Breton and his friends may have invented automatic drawing but Rapoport substitutes a computer program for a pencil. The drawing is not merely automatic but cybernetic, joining human consciousness with computer language to render an image as if from the ether. While she began by interacting merely with survey charts and computer printouts, she completes the cycle by scripting the interaction of others to generate a printout of her own devising. She has made her role as an artist functional in the structure of

the work, while at the same time making it unnecessary for her to draw upon the printout. In this work, it is the computer that completes the drawing.

Notes

1. Stephen Moore, "Introduction," *Sonya Rapoport: An Aesthetic Response* (exhibition brochure), Union Gallery, San Jose State University, Oct. 9–Nov. 3, 1978.

2. Sonya Rapoport, exhibition announcement, *Sonya Rapoport: An Aesthetic Response.*

3. Moore, "Introduction."

4. *Sonya Rapoport History,* http://etherart.net/srhist/hist1/index.html.

5. Charles Simonds, "From Macrocosm to Microcosm/Fantasy World to Real World," *Artforum* (Feb. 1974), 36–39.

6. Dorothy Washburn, *Interaction: Art and Science,* Truman Gallery, New York City, Jan. 12–Feb. 3, 1979.

7. Lucy Lippard, *Six Years: The Dematerialization of the Art Object from 1966–1972* (Praeger: New York, 1973).

8. Harald Szeeman et al., *Live in Your Head: When Attitudes Become Form. Works-Concepts-Processes-Situations-Information* (Bern: Bern Kunsthalle, 1969).

9. Sonya Rapoport, "ShoeField," *Boxcar* 1 (1983), 70, and Sonya Rapoport, "A Shoe-In," *High Performance* 6, no. 2 (1983), 66.

10. Sonya Rapoport, "Digitizing the Golem: From Earth to Outer Space," *Leonardo* 39, no. 2 (2006), 122.

Turning Point: The Advent of Symbolism in the Art of Sonya Rapoport

Meredith Tromble

Sonya Rapoport, who was born in 1923, began her career as a painter in 1949, working in the then-current Abstract Expressionist idiom. Today she is known for science-related webworks that have gained her international recognition as a new media artist. From the home page of her website, sonyarapoport.net, one can access such biochemically influenced works as *The Transgenic Bagel* (1993–95; see Plate 27), *Smell Your Destiny* (1995; see Plate 29), and *Redeeming the Gene* (2001; see image in Daubner chapter).

For an artist of her era, Rapoport had an unusual degree of access to scientific materials through her husband, Henry Rapoport, a faculty member in organic chemistry at the University of California, Berkeley. She dates the beginning of her artistic interest in chemistry to around 1977, saying, "I was inspired by the images and diagrams that I found in my husband's scientific journals. Perusing them at first for graphical ideas I gradually became inspired by their content."[1]

Rapoport observed that the forms of scientific communication—the tables, diagrams, abstracts, and citations—conferred an aura of authority and truthfulness on their contents. She held scientific inquiry in deepest respect, while recognizing that the power of these standard forms was produced by their place in a system, a larger structure of beliefs. She embarked on a long series of works manipulating symbolic systems through associations, juxtapositions, and displacements of imagery, revealing the workings of the systems and uncovering hidden patterns of thought.

For example, in *Smell Your Destiny*, an interactive Web project that debuted at a time when the American market for Prozac and similar drugs had reached 150 million prescriptions a year,[2] Rapoport lampooned the practice of prescribing chemicals

First published as "The Advent of Chemical Symbolism in the Art of Sonya Rapoport" by Meredith Tromble in Foundations in Chemistry, Spring 2009. © 2009 by Springer Netherlands.

to cure ills of the personality. The site leads viewers through a parodic system of correspondences constructed with reference to the habits of various fish species. Following the pictorial charts, one can self-prescribe aromatherapy with fishy fragrances to stimulate desired traits: a sensitive person might build their courage by smelling a devil fish, which attacks when approached; a solitary person might be prescribed the smell of grouper, a gregarious fish. The kicker is that Rapoport includes charts for different historical eras. The personality trait considered undesirable by a twenty-first-century American might have been just the thing for a second-century Nazarene. Serious commentary on the role of relative, cultural values in defining "mental health" emerges from the joking, pseudo-medical aromatherapy prescriptions.

The use of visual metaphors and word associations to construct an interactive experience for the viewer is typical of Rapoport's mature work. She creates symbolscapes through which one travels, rather than unitary images—like paintings—that one explores through contemplation. One almost never sees a Rapoport work whole, all at once. Her works require time and activity—choosing, clicking, turning, or walking—to comprehend.

Sonya Rapoport
Photosynthetic Prokaryote/Ancestral Host Cell/Lion Eating Sun (working drawing for (in)AUTHENTIC, 2007
Mixed media
11" H x 8.5" W

A detail from Rapoport's website, titled (in)AUTHENTIC (2008), will serve to make a few general points about her visual strategies. Rapoport often uses visual affinities to establish a relationship between disparate images. In the working drawing for a Web page, she layers pictures that are clearly from different spheres of knowledge. The thick, angled lines mark the lion as a woodcut; the anatomical stylization harks to a time when Europeans didn't really know what lions looked like. Even if one didn't recognize the alchemical figure "Green Lion Eating the Sun" (probably based on an illustration in the sixteenth-century text *Rosarium Philosophicum*), one

would know that it was antique. The illustration of the cell, on the other hand, is recognizably modern. More than just modern, it is "scientific," with the flat, distinct colors, juxtaposed cutaways, labels, and pointers that are the visible signs of scientific illustration. But like the lion, the cell is a symbol, an image encoding a body of information. It is thoroughly conceptual; visual information that might confuse or obscure the points the maker wishes to convey has been edited out.

Rapoport connects these two symbols with visual rhymes. The lion and the sun are two objects in the process of becoming one; the two representations of the cell are meant to represent one body. The size and shape of the sun match the upper part of the cell with photosynthetic apparatus; the other part of the cell "inside" the lion conveys the thought that by taking the energy of the sun into the body, animal life is sustained.

In constructing the image, Rapoport used a tissue paper overlay to bring the lion and cell together visually without disrupting their individual integrity. Her action as an artist was not to make new marks, but to establish a system in which previously existing marks mirror and reflect meanings one upon the other. By leaving the symbols intact but bringing them into relationship, she allows the mystical and the scientific interpretations to coexist for the viewer.[3]

Objects on My Dresser

Rapoport was making interactive works using such juxtapositions decades before the Web existed. Her first interactive piece, *Objects on My Dresser* (1979–1983; see Plates 7 to 24), refers to psychology and linguistics more than chemistry. However, it contains an important clue to the symbolism in the series of works treating chemical elements that followed in 1979. In the transition from *Objects on My Dresser* to the *Cobalt* series, chemistry emerged as a central metaphor in Rapoport's work.[4]

Objects on My Dresser, which began in 1978, developed through five years and eleven phases of performance and installation. As Rapoport describes the core concept: "I had a random set of objects that had accumulated on my dresser over twenty years. There were twenty-nine objects that appear to me now as a very eccentric collection of stuff: a toy auto, plastic furniture cups to protect rugs, a satin pocket from a jacket…tiny ceramic hearts, etc. In 1979, I conceived a psychological analysis that focused on image-to-image and image-to-word associations as an art process. Psychiatric social worker Winifred De Vos and myself shared aesthetic and emotional responses about the objects and my associations with them. Winnie and I recognized the words and images 'as clues to pre-eminent concerns.'"[5]

Near the beginning of the project, Rapoport and De Vos created a table of associations that was used throughout the work in various ways. The following list appears at position number eighteen on the table: toy steel bank, death, casket. In one version of the piece, Rapoport's associative chains were coded on computer punch cards with the images printed on the face; viewers could rearrange the cards according to their own associations and the resulting arrangements were fed back into the system to create the next iteration of the piece. The original punch cards for association number 18 are

marked with a casket image that also appears in another part of the project: a print called *Periodic Table of the Elements*, from *Objects on My Dresser, Phase 10* (1979; see Plate 19).

Just as the name implies, in this print images of the talismanic objects from Rapoport's bureau occupy the periodic table. In position twenty-seven, where cobalt would normally appear, Rapoport used the same found image of a casket that had marked the punch cards.

While conversing about her art in her studio, Rapoport mentioned that she had been dealing with the death of her mother during the years that led up to the *Cobalt* series, and recalled the original association with "death" as the word "coffin"—the opening "co" and number of letters bringing the word association into close alignment with "cobalt." When the original word list was located, however, she saw that the term was "casket." She was dismayed at the slippage, yet this living experience of the unstable bonds between words and images, decaying and transforming in memory, seemed appropriate to the work, which is full of puns, metaphors, derivations, and doubles—symbols in unstable, oscillating states of meaning.

The Cobalt Series

This is apparent from the title page of *Horizontal Cobalt* (1979), one of four works in the series Rapoport made in collaboration with the nuclear chemistry division of the Lawrence Berkeley Laboratory of the University of California. Each of the four

The artist unfolding *Horizontal Cobalt* in her studio.
Prismacolor, transfer copy, continuous computer printout, 15" H x 143" W

is a ten-foot-long, seven-fold work on archival computer printout paper bearing data from an experiment in nuclear chemistry integrated with images and texts.

Horizontal Cobalt is representative of the series. The first page bears a family crest; the words "Rapo o porto" appear in reverse. As the name suggests, the first "Rapoport" was a rabbi from Portugal. The ancestral references connect Rapoport with her husband, her gateway to chemistry, but the piece may also be connected with her subterranean flow of grief for her own parent. Rapoport's maiden name was "Goldberg" and the element gold is another central symbol of the piece.

The coloring on the crest and the alignment of the letters are a bit messy and uneven—just enough to make sure the viewer knows that although the printer paper has associations with machines and regularities, this is a "handmade" work, with the personality of its imperfections.

The concept of change over time is embodied in the form of the document. Rapoport says she originally intended for the work to be hung on the wall, like a painting. But whether it is hung, unfolded scroll fashion, or viewed by turning pages, the small scale of the imagery and extreme length of the piece make it impossible to see everything at once. A viewer experiences the piece as an accumulating progression of imagery, just as the experimental and psychic processes it records were built over time. And one is literally forced to see the work from different viewpoints, just as Rapoport is looking at change from both scientific and mystical viewpoints.

The fundamental transformation represented on the paper is described in a train of numbers, data from an experiment directed by nuclear chemist Michael Lederer. Lederer's team placed cobalt atoms under nuclear bombardment, splitting them into other substances. At one (brief) stage, gold formed. The dream of the alchemists had been achieved. As Rapoport described it, "The cobalt died but became something else even more precious."

Working over the data printout, Rapoport elaborates the mystery of the transformation for those who might not be able to interpret the story told in the data—or who might feel constrained to interpret it only in scientific terms. She uses dozens of small drawings and texts, many more than can be discussed here, but the following examples may serve to communicate the flavor of the work.

The flow of imagery kicks off with blue figures dancing at the top of the printout. The dancers are a tribute to the artist Henri Matisse, who, as he neared the end of his life, created the transcendent *Jazz* series using cobalt-pigmented blue paper. They open the piece by associating cobalt with pleasure and creativity in art and in science, as the figures "dance" with the data.

The romance quickly thuds to earth, in typical Rapoport fashion grounded by a derivation and an association. In the next stretch of imagery, the dominant image is a dangerous-looking being labeled "kobold." Near it is a text tracking the origin of the word "cobalt," explaining that the mineral poisoned sixteenth-century miners who smelted it hoping for silver and got arsenic fumes instead. The miners named their disappointing metal "kobold" after legendary evil gnomes who worked underground.

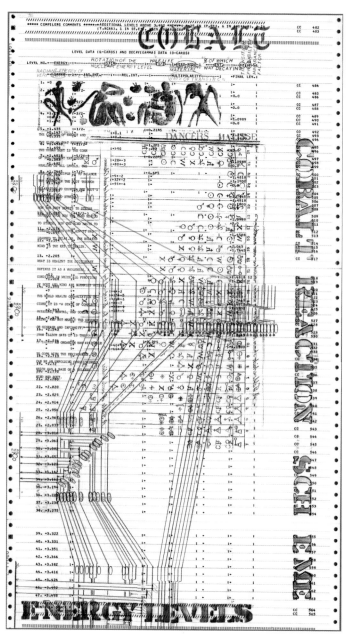

Sonya Rapoport
Vertical Cobalt (detail), 1979
Transfer print and colored pencil on continuous computer forms
110" H x 15" W

Sonya Rapoport
Horizontal Cobalt: Family Day at the Laboratory (detail), 1979
Transfer print and colored pencil on continuous computer forms
15" H x 143" W

Next up is a contemporary instance of releasing evil spirits, the hydrogen bomb. Cobalt was used in the production of the bomb; Rapoport brings the association home by reproducing a news image of the mushroom cloud accompanied by a headline that reads, "In Livermore the bomb is part of life. Families visiting LBL Family day at the laboratory: visitors walk amidst the H-bomb mock-up." This imagery was added to the printout by Xerox transfer; this printmaking process preserves the look of the original news story, lending authority to the image.

The bomb is followed by another news image—of malnourished sheep. Sheep, and other animals, need cobalt in the form of vitamin B12 to thrive. Rapoport chose the placement of this image on the printout to juxtapose the basic idea of animal health with the increasing energies activated by the experiment.

As the sequence progresses, Rapoport accompanies data for the moment of change from one element to another with imagery of alchemical or early chemical vessels. It is worth emphasizing that while the associations Rapoport loads into her

pages connect in nonlinear ways, she takes pains to report reliably on the nodes in her network of correspondences. "I didn't make anything up," she says, "Everything is very legitimate."

This statement is a telling example of Rapoport's philosophy. In other artistic contexts, "making things up" is the thing to do. But Rapoport's work holds in solution thought systems that don't normally mix; the pressure that keeps them in contact is the accuracy of her reporting. Every move she makes as an artist connects with an aspect of cobalt in the physical world. Her research may not be organized along disciplinary lines, but it is rigorous.

As the end of the sequence approaches, Rapoport sums up with a hopeful text message, "To a New and More Beautiful Life." Up to this point, the printed data and the images have fragmented and interrupted each other. As the sequence draws to a close, a stretch of the scientific data gains its own space. One system does not push the other into the background, both remain in the visual field, in consciousness, making their different claims.

She concludes with another alchemical image, the so-called "coniunctio," the union of opposites. Rapoport regards this image as particularly significant to her work. She states that "A key to my work is the synapse of two unlikely entities, a dissident or serendipitous pair triggered into dialogue. Chaos emerges from the convolution of these polar entities until a meaningful resonance is resolved."

In the *Cobalt* series, Rapoport juxtaposes a "failed" system of thought—alchemy—with its "successful" daughter system—chemistry. At this juncture, the dated quality of the computer printout paper suggests that the truths of nuclear chemistry may be just as vulnerable to the passage of time and the change of context as the truths of alchemy were. Rapoport finds a story of transformation and hope in the passage of cobalt through "death" and transformation into another element, but it is told in counterpoint with examples of the pain and sacrifice involved in transmutation.

Throughout she uses visual juxtapositions to remind viewers that alchemy attempted questions that chemistry has not answered and to suggest that viewers cannot simply sweep past those questions, because they continue to trouble human life. However, her work does not support a notion of alchemy as a spiritual pursuit that might be opposed to a materialist science. Rather, it suggests the importance of leaving open spaces for new meanings to emerge and models an approach to knowledge that stresses questions and humility rather than answers and dominion.

With the *Cobalt* series, Rapoport had found her pictorial voice and her subject matter. Nearly three decades later, she continues to work, as an artist, with science, looking for "authentic research projects that are interesting to me, preferably with captivating pictorial subject matter." The ramifications of the *Cobalt* series continue to grow as, at the age of eighty-seven, Rapoport is constantly working on new projects and using alchemical and chemical symbols in new contexts. But the first decade of her work related to science received little critical attention, due in part to social attitudes that obscured the contributions of artists who happened to be female, and

to related attitudes that hewed to hard divisions between "artistic" and "scientific" content. But as these belief systems have begun to erode, the significance of Rapoport's early work is coming into view. As a pivotal moment in the development of her artistic language, the *Cobalt* series will continue to be a touchstone in the discussion of Rapoport's work.

Notes

1. Sonya Rapoport, interview with author, Berkeley, Calif., July 21, 2007.

2. David Stipp, "Trouble in Prozac," *Fortune*, Nov. 28, 2005 (available online at http://money.cnn .com/magazines/fortune/fortune_archive/2005/11/28/8361973/index.htm).

3. The range of possible interpretations can be suggested by two examples. In "The Radiant Wisdom Stone," John Lash, who describes his field as "metahistory," offers a literalist reading in which he calls the Green Lion "a naive symbol indicating how sunlight converts to chlorophyll and thus provides vital energy" (http://www.metahistory.org/GRAIL/StoneWise.php, accessed 12 February 2008). Religious historian Karen-Claire Voss argues that "Symbolically this depicts a stage in the development of the alchemist where the illumination that was previously regarded as outside, 'other,' to himself, is now being assimilated into his or her very being" (in *Gnosis and Hermeticism from Antiquity to Modern Times*, ed. R. van den Broek and W. J. Hanegraaff, New York: State Univ. of New York Press, 1998; available at http://www.istanbul-yes-istanbul. co.uk/alchemy/Spiritual%20Alchemy.htm, accessed 12 February 2008).

4. It was not simply chemical imagery and symbolism that fed Rapoport's work, but also interaction with chemists. In a 1995 dialogue with Anna Couey and Judy Malloy, Rapoport told a story about the advent of interactivity in her work that nicely demonstrates one aspect of the way her position in the University of California chemistry department social network contributed to her artistic development: "a group (about 40) of my husband's chemistry graduate students and post-docs were coming over for Thanksgiving dinner. For their entertainment, I drew on my studio floor two NETWEBs, mine with my own associative distribution of card images placed along related theme axes; and the empty plot for them to fill. Very amenable and bright and interested in my artwork, the group viewed the configuration that reflected me, the artist, and were excited to reconstruct their own configuration. Winifred interviewed and taped each participant's response as to choice of image card and why the placement in the particular theme. The verbal inquiry heightened the sense of participation, intensified the vitality of the process, and provided documentation. So I added another phase to *Objects on My Dresser*." (The dialogue from which this is quoted is reproduced in the Couey and Malloy chapter of this volume.)

 "NETWEB," a term Rapoport began using around 1981, is her word for a spiderweb-like drawing or construction showing the associations generated by the objects from her dresser; Rapoport later made an installment of *Objects on My Dresser* that compared the associative webs produced by artists, scientists, and lawyers.

5. This and all subsequent quotations from Sonya Rapoport in this chapter are from the Sonya Rapoport interview, July 21, 2007.

From Alchemy to Bioweb: Metaphors of Transmutation and Redemption

An Interview with Sonya Rapoport

Ernestine Daubner

An innovative artist, Sonya Rapoport began creating computer-based multimedia interactive installations that referenced science and (bio)technology in the 1970s. As a pioneering Internet artist, she first introduced the term "transgenic" into an artwork in 1993, in her interactive installation *The Transgenic Patch: Cellular & Psychological Transformation*. Though never fully realized, in the same year this project evolved into her interactive computer-based artwork *The Transgenic Bagel* (1993–96; see Plate 27), a parody on recombinant gene splicing. Replete with irony and humor, her subsequent bioweb artworks are rich commentaries on sociocultural issues. In her recently released bioweb work *Kabbalah/Kabul: Sending Emanations to the Aliens* (2004; see Plate 28), Rapoport offers stem cell research as a means to counter the destructive nature of the war machine.

Even though Rapoport frequently refers to cutting-edge scientific research, she interweaves such references with ancient mythologies, biblical narratives, and popular culture. Her various works function, in diverse ways, as ironic critiques of cultural constructs and customs, past and present, while at the same time including metaphors of transformation and alternate ways of being: the possibilities of morphing, of reconstructing personal traits and collective customs. Conveying a cyborgian condition of hybridity and fluid boundaries, her works are always dynamic in that notions of transgender, transethnicity, transculture, transgenics, trans-(…) operate as

This interview was first published in French as "De l'alchimie au bioweb: les métaphores de la transmutation et de la rédemption" in *Art et biotechnologies,* ed. Louise Poissant and Ernestine Daubner (Montreal: Presses de l'Université du Québec, 2005).

a means to cross over, fuse, or meld disparate, often hierarchical, elements on the one hand, and to reveal the ethical and moral implications on the other. In several of her works, the golem functions as her avatar, operating as the vehicle for mutation or change, and as a metaphor of hope and redemption. In this interview, Sonya Rapoport discusses her various works and their relation to science, technology, and culture.

You began your artistic career as an Abstract Expressionist painter and then, in the 1970s, you shifted your interest away from painting, becoming one of the first artists to create computer-based works relating to scientific models. Many of these were computer printouts that interpret different areas of scientific research, such as botany, nuclear science, and genetics. Were there other artists working in this area who influenced you? What drew you to science and to biotechnology in particular?

I knew of no artists who referenced science in their work and, in those days, certainly none in the area of biotechnology. Married to an organic chemistry professor and bringing up a family, I was isolated from other artists. My social life revolved around chemists. They were able to provide answers to whatever science questions I may have had.

Although not particularly sympathetic to the arts, my husband had a profound influence on me as an artist. Organic chemists work with the classical concepts of chemistry. They research the tools which aid in the basic understanding of biotechnology. I became interested in the related field of biotechnology because it addresses human concerns such as gene splicing and cloning.

Initially an abstract visual artist, I was later inspired by the scientific images and diagrams that I found in my husband's scientific journals. Perusing them at first for graphical ideas, I gradually I became inspired by their content.

Arriving at an aesthetics that merged art and science was neither a deliberate nor a direct process. I had to feel my way out of my Abstract Expressionist hangover and incubate what I was absorbing from a different world. At first I eased into my new direction by making "combine" paintings. At least one of the two or three separate canvases that were nailed to the "combine" canvas support referenced a scientific topic. I recall one image of bloated intestines. The sister canvases of the "combines" echoed via drawing, painting, and collage the familiar turf of Abstract Expressionism.

These works were exhibited at the San Francisco Museum of Art in 1964 and at the John Bolles Gallery, which represented me. In the reviews of the exhibitions, the nailed canvas supports, unusual for that time, caused a stir. The content of the work was overlooked.

You are also a pioneer Internet artist. What appealed to you about the Internet as a medium for your art practice?

As a pioneer at the onset of the Internet, I was presenting interactive art projects on personal computers. This was in the 1980s, before the popularized Web. As soon as the Web became a public space, I began using it as an art form. It was the perfect tool for combining words and images. Using this technology, I, as artist, was proselytizing not only technology as an artist's tool but as a hybrid aesthetic of science and

art. I used metaphors to ease the frisson that some of my viewers experienced when confronting my science-based subject matter, and sometimes to clarify what might otherwise be obscure subject matter. I wasn't necessarily trying to include a literary component. My approach has always been intuitive. The variety of tools provided by the Internet allows a story to be told in many ways. There isn't a finality to the work as there is in painting. This fluid product for the Internet can be dressed and re(ad) dressed with many flairs/flares.

What is striking about the various works throughout your career, and particularly your later webworks, is the way you interweave scientific (and biotechnological) references with cultural inscriptions as if you were, in some way, wishing to animate, or perhaps contaminate, the pure, objective discipline of science. Would you agree with that formulation?

Yes. "Contaminating" (I like your word) science with cultural references is a method I handle with passion and confidence. I don't use the word "contaminate" negatively. Contamination can enrich the material with humor and parody and extend the work into further meaningfulness. As well, the infusion can aid a greater comprehension of the scientific application. I enjoy the nourishment from mixing cultural recipes with a scientific potpourri. Sometimes I wonder whether I am a reincarnated social anthropologist.

However, if I found myself in a science laboratory with a patient scientist beside me for a long enough period of time, I might try to create an art piece without including social parameters. The experiment would inevitably be of little scientific consequence but there would be the possibility of aesthetic innovation.

In order to whet my creative taste buds, the artwork must contain some quirk of humankind. I listen carefully to differences and enjoy communicating with them. I am compelled to assimilate unlikely matches in order to "animate" and integrate science into living life. Once the scientific material is understood and simplified, the cultural inscriptions are interwoven. The science matter can be expanded and diversified, challenging the integration of extraneous material.

My husband's experiments with natural phenomena required visits to exotic lands where governments contracted him to synthesize their indigenous botanics. I would have preferred to go to famous art centers but there was no room for both. While becoming acquainted with chemical challenges in government laboratories, I was assimilating foreign customs.

Yes, in many of your bioweb works, you integrate issues relating to ethnicity and gender with references to science and (bio)technology. There are also many cross-references within your various works. Could you elaborate on this?

I am always surprised when I return to my earlier work and find connecting threads regardless of time separation. Thirty-five years ago, I had sequestered in my Pandora Cigar box a collection of diverse shapes, icons, and hunks of oil paint stuck to small pieces of discarded canvas. It is a "*Pandora's Box*" (see Plate 1) because the contents harbored inflammable frustrations. Ten years later I interpreted these fragments to

be a female code for arcane communication. I first depicted these symbols on survey charts and then encoded them into a cryptic dialogue on random computer printouts. These symbols related visually and spatially to the printed numbers and characters I found on the computer printouts. I gave clues to my subliminal messages in the titles of the artworks. A few examples are *The Bersanding Experience (Malaysian Marriage)*, *Muslim Wives Study 1*, *Binding*, *Fight to Overcome*, and *Ketuba (Hebrew Marriage Certificate)*, all completed in 1976. My latest artwork (as of 2001) that addresses the gender issue is *Redeeming the Gene: Molding the Golem and Folding the Protein*, a work that endeavors to absolve the purported guilt of Eve and Lilith.

As I traveled with my husband from country to country and culture to culture, I witnessed female degradation beyond imagination—harsh and irreconcilable. While in India, birth control was the current public contention. Males believed a rumor that birth control would require them to be castrated. This spurred me to create an artwork about the psychological impact of birth control upon the male ego. The inventor of the birth control pill, Dr. Carl Djerassi, was an acquaintance of mine and my husband's.

As far as ethnicity is concerned, I do not believe in erasing ethnic differences but in tolerating them. I would love to save the identity of every culture. My Web piece *Arbor Erecta* (1998) describes primitive rituals that involve barks, roots, leaves, and other botanic provisions that relate to Ayurvedic and Chinese herbal medicinal cures.

For over thirty years, you have studied and represented diverse areas of science and biotechnology in your artworks. How do you, as an artist, view the relationship between art and science, as well as the differences between an artistic creation and a scientific experiment?

A scientific experiment is not necessarily creative. The experiment could be a

Sonya Rapoport
The Bersanding Experience, 1976
Computer printout, yarn, graphite, Prismacolor, rubber stamps, typewriter text
Cross-cultural references of a two brother wedding in Penang, Malaysia.
90" H x 55" W

Sonya Rapoport
Redeeming the Gene: Molding the Golem, Folding the Protein, 2001
Interactive website
Dimensions variable

technological procedure for expediting an idea. The idea that formulates the experiment or the way the procedure is directed or interpreted for further application may be considered creative. In art, the application of an idea is more commonly viewed as its creative feature. However, the concept may be thought of as the stronger creative factor.

Regarding the creative process, the scientist must be educated rigorously before s/he can be innovative. Getting ideas, incubating them, experimenting with trial and error, and evaluating results are probably similar in each discipline. To recognize the potential of the product, to have the confidence to take risks, and to have the stamina to follow through are key to both the experiment and the sketch. Occasionally coincidence is serendipitous but someone must be out there to recognize it.

Those working in the humanities deal more directly with human concerns, and employ a less structured scientific methodology. However, some social scientists may claim that they apply scientific procedures in their research. This could be partially true but scientists have a more objective method for a more distinct target. I hesitate to say less human and less cultured because I am reminded that Melvin Calvin, who received the Nobel Prize for photosynthesis, declared about thirty years ago that a person wasn't cultured who was not scientifically literate. Those involved in scientific research are at least as creative as artists and find as much excitement in its creative

unfolding. That science is dry or distant is a public misconception. Curiously, the tables of these traditions are being overturned. A cellular scientist can be said to have a human objective while an electronic artist's objective can be a technological device.

The scientist's role is said to advance the understanding of the world; the artist's role is to entertain or describe it. This is an old adage. These roles are now interchangeable, compatible, or radically different, depending on what science and which artist. I think of my work as doing a bit of both, but mostly I think of it as a contentious vehicle for aesthetic and provocative cultural rethinking.

Introducing the extraneous/cultural material exerts my control over the scientific. I manipulate the science so it becomes vulnerable to the influence of the art concept. I am then able to interweave the cultural and scientific data.

There is the consideration of what kind of artist the artist is, traditional or electronic. I have found very few electronic artists, especially the young ones, to be familiar with art as we learned it in art history.

Would you say that your artistic manipulation of scientific drawings and processes is your way of bringing a kind of chaos, convolution, or serendipity into what is otherwise a very rigorous method of research?

As I understand these words, there are differences in the meanings of chaos, convolution, and serendipity. You have untangled the sequence to my art process, although it may be in almost reverse order. A key to my work is the synapse of two unlikely entities, a dissident or serendipitous pair triggered into dialogue. Chaos emerges from the convolution of these polar entities until a meaningful resonance is resolved. The restricted parameters of the science in my work become more elastic and allow integration with the other material.

Let's focus on specific works, beginning with your early computer-based works of the 1970s, many of which were computer printouts.

My breakthrough with the computer printout idiom was precipitated by the fortuitous find of geological survey charts in an antique architect's desk. Similar to performing a litany, I painted the same shapes that I had, since the 1960s, deposited in the aforementioned Pandora Cigar box directly on these survey charts. The shapes became integrated visually with the charts' topological schema and related conceptually to the geological dissections of earth and water.

In 1973, after two years, I replaced the survey charts with randomly selected computer printouts upon which I superimposed sets of symbols from the *Pandora's Box* with pencil drawing, rubber stamps, and color graphite. The letters and numbers that I found on the printouts challenged me to visually synthesize the ready-mades with my feminist art language code. This move was my entry into using language as an art tool. Later, questioning the anonymity of the printout and its arcane meaning prompted me to ask our scientist acquaintances for their discarded research output. I wanted to learn about future codes upon which I would be contextualizing messages.

In Journey *(1976), you link birth symbols with botanical research printouts. What is the link between them?*

I drew an overlay of the birth symbols and the extra X chromosome for the female gender over computer forms that my daughter gave me from her botany graduate group. *Journey* became the title of the artwork, a hybrid of a gender journey of coded text and a computer model. Subgol, the computer model, describes a dynamic integrative physiology of the sugar beet crop, how it grows and develops. Metabolic efficiencies are due to mitochondria, which are small bodies within the plant cells where respiration is carried out. Mitochondria, which is handed down almost exclusively through the female, creates most of the cell's energy. A visual void that resembles the shape of a beet appears in the artwork as the continuous tracing where the birth symbols join.

Mirror (Image) of Nature *(1977) is a series of drawings and copy transfers of rats and herbal plants, and your first biotechnological artworks, in that you represent the genetic transfer of brain tissue from trained to untrained rats. The scientific method of synthesizing herbal drugs for medicinal use is also explored. These early works anticipate your subsequent interest in the transformative possibilities of biotechnologies. Could you elaborate on this?*

In this work, we see an early scientific attempt to transplant traits as though in anticipation of gene splicing. *Mirror (Image) of Nature* describes research for control over both intelligence and nature. The artwork, imposed on output printed from the BrainChm computer program, is an analysis on the changes in weight, DNA, and chemical activity of rat brains through variations of the transfer of brain tissue. The second background underlay imposed over the BrainChm printouts consists of molecular equations. These equations illustrate the alteration of natural phenomena

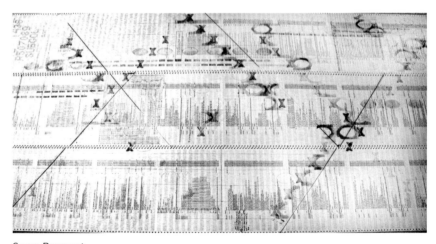

Sonya Rapoport
Journey (detail), 1976
Computer printout, graphite, Prismacolor, Asian character rubber stamps, yarn, typewriter text
88" W x 44" H

and mode of therapeutic action of drugs through cellular receptor targets. Drawings of herbal plants relate to the molecular changes described.

Goethe's Urpflanze: The Primal Plant *(1978) is also described on a computer printout. The scientific research refers to the biological effects of pollution in altering the bean plant attributes. Were you interested in documenting or representing the effects of pollution here? How do Goethe's theories relate to this?*

I was interested in relating the coincidence between Dr. James Bennett's 1978 research on air pollution and Goethe's 1817 alchemical concepts. Both had involved research on the bean plant within the broader scope of the cosmos. It was the first art piece that I had made on archival computer forms, i.e., computer forms manufactured with rag content. I had given these forms to Dr. Bennett so that he could reprint his coded experiment on them. Also, it was the first artwork in which I had superimposed drawing overlays and transfer images of a subject related to the printed code. I was involved in an artistic interchange between subject and code. At that time I was looking for authentic research projects that were interesting to me, preferably with captivating pictorial subject matter. Once I located the project and elements thereof, then came the challenge of getting the research data reprinted on the archival computer forms. Finally, the chaotic creative process of resolving a cohesive product that combined scientific research with art concept came into being. Serendipity had played a role when I learned that Dr. James Bennett, my daughter's friend, worked with the effects of air pollution on the bean plant at Davis, the prestigious agricultural research center of the University of California.

The artwork, *Goethe's Urpflanze,* consists of drawings and copy transfers of Goethe's model of the primal plant. Their graphical images are superimposed directly on the printouts of the biological effects of environmental pollution on the bean plant. For Goethe, the plant's double pod represented unity in duality. I depicted imagery from Goethe's theory of the Golden Chain on the pollution research. Goethe's theory is a theory of opposites based on the supposition that man and the universe act in accordance with similar laws.

From my overlapping layers of research on a variety of topics, I became informed about alchemical experiments. Pivotal to my future art production, this material prepared me for my work on transmutation.

Yes, the three works **Horizontal Cobalt** *(1979),* **Cobalt** (Vertical) *(1978), and* **Mercury** *(1979) link nuclear science with alchemical transmutation.*

Among my strongest works are drawings on nuclear science printouts from the Lawrence Berkeley Laboratory. The scientific project entailed the process of making gold by the transmutation of elements. In the drawing overlays I decoded the nuclear bombardment schemes beginning from the decay of the elements to their regeneration to a new identity. I contextually interpreted this process as updating alchemy. This concept gave me the opportunity to depict visually the images that Jung used in his book *Psychology and Alchemy.* Among the images was the birth of the homunculus, the little man in a test tube.

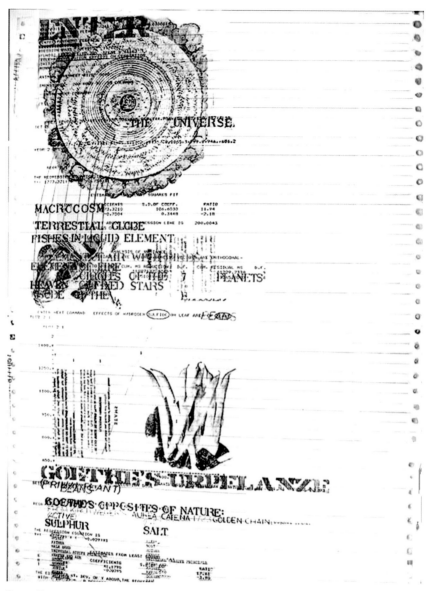

Sonya Rapoport
Goethe's Urpflanze (detail), 1978
Computer printout, Prismacolor, graphite, transfer copy, typewriter text
88" H x 15" W

Could you elaborate on the interrelationships between alchemy and genetic technologies, i.e., transmutation of elements, the homunculus, and genetic technology? What are the commonalities and differences, in your view, between these historically distinct beliefs and practices?

The key word to the interrelationships is transmutation. When I learned that the Lawrence Berkeley Laboratory actually had discovered the "recipe" for making gold in 1977, I immediately thought of the alchemists' quest for the Philosopher's Stone that would change base metals into the noble gold and silver. I was not aware at that time that transmutation, in this case by nuclear bombardment, would also apply to genetic technology by other means. I was busy interpreting nuclear chemistry, a discipline far away from biogenetics at that time. The output's attractive imagery of the transposed decay scheme graphics motivated me to incorporate other science-related subject matter. Nevertheless, I was fascinated by the image of the little man, the homunculus in the test tube. I superimposed on nuclear-research printouts images of the early flasks and ovens, the appliances that were used in alchemy, with the idea that the birth of the homunculus can issue from an amorphous mass. That a perfected life and spirit will emerge from a semiorganic mixture of flesh, blood, and urine is a conceptual commonality with today's genetic cloning technology. The knowledge of modern chemistry changes the mysterious magic into actual possibility. In 1993, Natalie Angier, in the *New York Times,* reported the transformation of a "single fertilized egg into a breathing, sentient, multicellular being."

The Transgenic Bagel *(1993–96) was the first artwork that referenced the science of transgenics and your first webwork, wasn't it?*

Hypercard, then Macromind Director, then Web software, were the technologies I used to realize the phases of *The Transgenic Bagel. Smell Your Destiny* (1995; see Plate 29) was my first webwork. *The Transgenic Bagel* was transcribed from other software for Web viewing at around this time.

In the scientific sense, *The Transgenic Bagel* was my first realized transgenic art piece. As I review my work from the mid-seventies, it seems that I was always "transcending" something. Perhaps this could be the motivation for creating the art that I do. I am obsessed with modification, especially self-modification. Then, of course, I scrutinize others' artworks for what modifications I would make to them if they were my own.

As for the use of the word "transgenic" for art, which is very popular these days, my then-collaborator Kathryn Woods and I coined the phrase around 1992 when we needed a title for *The Transgenic Patch.* Since Kathryn was aware of the term "transgenic" in her scientific work, she unearthed it and used it as a title for the artwork. I later applied it to *The Transgenic Bagel* when I became the single author of that work.

The use of genetics in *The Transgenic Bagel* has a parodic twist on the transference of a trait gene. A selected trait is accessed by inserting a hypodermic needle into an animal to withdraw a sample of its particular trait. A lion's authoritative trait would be an example.

In *The Transgenic Bagel*, the graphical and contextual procedures for modifying the trait gene are accurate according to the procedures of science. I replicated the process by which recombinant DNA is created based on what I had seen in a science videotape. This included the genetic search, the mapping, and the splicing programs for the preparation of a genetic formula. Thus, the processes in *The Transgenic Bagel* mirror exactly those found in valid scientific processes.

The animal trait, having been processed into a new genetic formula, is injected into the bagel fragment. This fragment is fitted into the cleavage of another bagel, the fragment vector. The two bagel components are then joined and cemented by cream cheese. To acquire the trait the participant then eats the bagel chimera. Thus, the scientific leads to the artistic.

In both The Transgenic Bagel *and* The Transgenic Patch *one sees reference to the manipulation (or transmutation) of genetic makeup (the body of science) and the transformation of the psychological body (the body of the humanities). The body posited by science and the body inscribed by the humanities meld together. To what end?*

I like to think that the "melding" was virtually to change the genetic makeup of the participant, i.e., to transfer a "happier" trait into his/her body/psyche. At that time (1993), only the body was considered to be vulnerable to genetic splicing. The idea of psyche alteration was noted in an editorial about *The Transgenic Bagel* in *Nature* (1997). Now, in 2007, the psyche is a candidate for trait transference.

The interweaving of the theme of gene manipulation with transformation of personality traits is mingled with humorous and ironic references. Indeed, humor and irony are significant elements in your various works, aren't they?

That is what makes it fun. This is my fun. The humor and irony come naturally, most often in the shower. My friends say I am always living with my art, so ideas inevitably pop up all the time and everywhere. I carry on conversations with myself. I often wonder about people walking and driving while talking on cell phones. When do they ever have time to think or exchange ideas with themselves?

Your webwork Smell Your Destiny *(1995) is full of humor. However, the word "destiny" appears anomalous in terms of your other works—it seems ironically to contrast with the idea that one has the ability to change one's destiny (genetic identities) and personality traits. Could you say anything about this?*

A terse and catchy title can inadvertently obscure the artist's intent. *Smell Your Destiny* is a work about genetic modification and does imply that destiny can be changed.[1] The residents in my fictional community could move out of the community or rally against having the fish in the pool if they were opposed to absorbing the trait smell. There is therefore an implicit choice to be made in not inhaling the consensual trait smell. In any case, fixing a given destiny is not the point of my work; in fact it is just the opposite. Perhaps we can say that the irony of being able to change one's destiny is consistent with the irony in my work.

The piece is a parody of fickle values and marketed pharmaceuticals; a fun but biting format. The scientific process in *Smell Your Destiny* is questionable. There are some people who firmly believe in aromatherapy. I apply it to myself upon occasion. In India there is the tradition that smelling fish clears the brain. Many students in Calcutta go to the fish market during examination periods to breathe in the fishy smell to help their thinking faculties. I have not heard about the uses of fragrance as a genetic tool but there is that possibility. A big market for smelling cures has been developed.

In your webwork Arbor Erecta: A Botanical Concept of Masculinity *(1998) you address issues of gender and ethnicity, and in* NETWEB *(1998–99), these gender issues are incorporated with references from popular as well as Hebrew culture. These works are potent critiques of patriarchy, aren't they?*

Although the works are intended to be critiques of patriarchy, in most cases the narrative reverses the procedure and emphasizes positive female traits which are emulated by the male.

In *Make Me a Jewish Man* (see Hava Rapoport chapter), the development of the boy parallels the morphology of the growth and cultivation of the olive tree; its horticultural hermaphroditic counterpart. Among the images depicted is the electromicrograph of an olive pollen grain. This 3-D image of the structure of the protein content in the outer wall designates genetic specificity. This identification is significant for perpetuating the genealogy of male lineage, kinship, and procreation.

In *Arbor Erecta; A Botanical Concept of Masculinity,* New Guinea tribal initiation rituals purge from the male body the female pollutants acquired from the mother. Female purging and male confirming is accomplished through tree bonding with the Pandanus tree: touching and shaking the tree, chewing its leaves, drinking its sap, and burying pubic hair in its trunk.

In Redeeming the Gene *(2001) you base your bioweb work on a preexisting trans-genic art installation, Eduardo Kac's* Genesis *(1999). Your work deals, in a complex and very ironic way, with contaminated or distorted morals and the dream of perfectibility. What drew you to Kac's* Genesis *in this regard?*

The initial interest that drove me to Kac's *Genesis* was Kac's application of biblical and genetic material. Here was my opportunity to expand upon a previously realized art and science project of interest to me. I have championed emulating in art the practice that exists in scientific research, which is to say that each artist takes what is of interest to them from the previous generation's works or from works by one's contemporaries and expands upon it. I felt this practice would provoke a future development in the arts. I had been looking for an artwork that resonated with my own work in order to provide an example. Kac's *Genesis* would provide a rich dialogue, one which he, in fact, openly invited. The title intrigued me on the level of my own ethnicity. I did create a *Genesis* of my own, in 1976, which was a visual language translation of the first Book of Genesis. It was a very early venture into using language as art. I color-coded letters

and words that repeated the biblical text. I had traced the letters and words from an alphabet template in a decorative way and applied the letters directly onto a found computer printout. To enable the viewer to find his/her place in the Bible I provided a legend of color patches and biblical phrases for decoding this fifty-two-foot-long work. The introduction of each of its three sections has a title page that simulates an illuminated manuscript.

I felt that Kac's *Genesis* raised moral issues to which I needed to respond. I am not as fazed by Kac's philistine, and some say negligent, use of gene technology as I am by his shunning the Hebrew source of the biblical sentence "Let man have dominion over the fish of the sea, and over the fowl of the air, and over every living thing that moves upon the earth" (Genesis 1:28) in favor of the American/Morse code–based alphabet.

Could you elaborate on your choice of the Hebrew source of the biblical sentence?

The original source of the sentence is in Hebrew. Therefore, had Kac used Hebrew as a source to create his "Artist's Gene," he would have been making a more impartial or universal choice.

Why does Kac's synthetic gene, which he created from the King James version of the biblical sentence and the Morse code, need to be redeemed?

Kac's DNA strand was synthesized from an English translation of the Hebrew sentence, thus giving the English language dominion over all other languages to create a living form. The English-derived gene arbitrarily posits a hierarchy to which Eve and Lilith object. So these women proceeded to redeem the gene by constructing a DNA strand from the original Hebrew.

Secondly, the gene was tainted by association with Samuel F. B. Morse. He was an unsavory political character who supported slavery and believed in Manifest Destiny. Kac used the Morse Code for transposing the English words in the sentence into dots and dashes. He then substituted these and the spaces in between the letters and between the words with the four nucleotides, A C T G. Eve and Lilith applied Gematria, i.e., Kabbalah numerology to arrive at the DNA base pairs.

In Redeeming the Gene you also inserted Eduardo Kac's face in place of Adam Kadman. Could you elaborate on this?

Adam Kadman is the Primeval Man, "a Kabbalistic term applied to the spiritual prototype of man, existing as an incorporeal intelligence."[2] Replacing Adam Kadman's face with Kac's face is a way of showing that Kac, as author of the artwork *Genesis* is redeemed.

Lilith and Eve play fundamental roles in the redemption of Kac's synthetic gene, don't they?

Retaining the Hebrew of the biblical sentence is fundamental for the redemption of the gene. By creating the Kabbalah (moral) gene, Lilith and Eve are absolved of their purported guilt.

To arrive at the four numbers needed to be replaced by the base pairs, A C T G, Lilith and Eve count the number of letters in the original Hebrew sentence. This is 39. Then they count the number of words in the sentence. This is 10. The sum of these numbers is 49. Then 49 is combined with 18, which is the number of unrepeated letters in the sentence. The four numbers 1, 4, 8, 9 are assigned to the Hebrew letters in the sentence in the order of appearance, generating the sequence 1, 4, 8, 9, 11, 14, 18, 19, 41….The numbers are then transposed to the components of the DNA molecule.

The contemporary contentious ethical theme of the validity of the biblical sentence remains unresolved. I'm in accord with Rashi, a twelfth-century French Jewish philosopher. His interpretation of the sentence is "If man is worthy he rules over beasts and domestic animals; if man is not worthy he becomes inferior before them and the beast rules over him."

Your references to Kac's Genesis *and the redemption of his gene are one thing, but you have also constructed an elaborate webwork that deals with genetic engineering. Could you explain this?*

The navigation scheme of *Redeeming the Gene, Molding the Golem, Folding the Protein,* reflects the genetic technological environment. The double helix, represented by a bar located at the bottom of each page, indexes the chapters in the artwork. If the viewer clicks on the double helix it causes an assembly of amino acids to unravel toward the golem protein at the top of the page. The amino acids are numbered to indicate the pages in the artwork. The characteristics of the golem protein, e.g., how it folds, are determined by the protein template in the participant's choice of chapter along the helix bar.

Could you say something about the golem and how it operates in your works?

To describe a golem, one could say that its contemporary counterpart is a robot. Historically it is a mythical creature molded out of a mound of mud in rhythm to a ritual of dancing and of chanting Holy Names led by a qualified righteous person. During the fifteenth century, under the influence of alchemy, Jewish legend associated the golem with Kabbalah. The concept of the golem evolved into a living being created for the purpose of performing altruistic deeds.

The golem is a positive force rather than the destructive entity on which Mary Shelley based her story of Frankenstein. In the artwork *Redeeming the Gene, Molding the Golem, Folding the Protein,* the golem is constructed with a moral Kabbalah gene that carries altruistic messages.

The golem I have created and modified genetically has played many roles in my life and my artworks. It has been my mascot, my puppet, an artificial intelligence. The golem holds my hand and I hold its hand. I am manipulating it so that it performs good works for humanity. In the autobiography of my art history the golem plays the role of my alter ego. Here is a quote from the introduction: "It is not unexpected that after creating golems in artworks for several years I am now wondering whether

I have been molding a reflection of my own self into the ultimate golem, the creative golem, an art producing golem or a golem producing art."

Looking back at your various works, one can observe how the themes of transformation and mutation operate as a dynamic force, providing a vehicle for change. At the same time, the possibility of change reveals an underlying dream of human and societal perfectibility. Would you say that your works deal fundamentally with moral issues?

The validity of the aesthetics is not defined by the moral issue. Scientific themes of transformation and mutation have provided a vehicle for change in my work since 1977. Even the more recent *Kabbalah/Kabul* (2004; see Plate 28) contains multiple scientific procedures: stem cell differentiation, gene splicing, injection of stem cells, stabilizing stem cells for replication, destroying evil viruses, genetically altering foods, and a description of the blowfly's life cycle. Nevertheless, in the titles of my pieces I include hints of moral intention which convey the moral issue. The realization and clarity of the art concept is my primary goal. I treat the contentious themes of gender bias, racial discrimination, etc. as objectively as possible. Invariably, I sprinkle them with both indignation and irony. I don't consciously view societal perfectibility as a goal. At times I have referred to my work as a vehicle for healing, a pathway to awareness rather than an aggressive dynamics.

Your recently released bioweb work is **Kabbalah/Kabul.** *In it, there are cross-references with your previous work* **Redeeming the Gene.** *As the title itself discloses, in this work you also interweave current political events in Afghanistan that have stunned the world and references to Hebrew culture. If hope and redemption played a significant role in your other works, this one appears much darker. Would you consider this a post-9/11 work that illustrates a shift in your preoccupations?*

I wasn't aware of a shift but perhaps there is one. We are all stunned and apprehensive and this apparently is reflected in my work. Both works you mention have scientific themes that interface with a global awareness. In *Kabbalah/Kabul* I was preoccupied with transmuting traits and splicing species for benevolent outer space intercommunication. Scientific laboratory efforts are currently directed toward modifying mosquitoes so they become incapable of transmitting malaria. Bees are being researched so they will be able to pollinate a resistance to special diseases. Spiderman was mutagenically altered by a bite from a spider; and I virtually altered the blowfly's DNA. The golem, in both the artworks *Redeeming the Gene* and *Kabbalah/Kabul,* addresses unfulfilled righteous needs. The former work performs the function of replacing a corrupt gene with a moral gene and, as well, absolves an unjustified biblical guilt; the golem in the latter piece is on a benevolent mission for communicating altruisms.

I regret a decline in wit in my artwork. You are correct in that the more recent piece is darker. The visuals incorporate images of the Afghan people. Their depiction, intended to be compassionate, is contentious for many. However, humor surfaces in narrative fantasy; hope lies in spreading altruisms and reflecting upon them. You perceive a drive for perfectibility; I perceive it as an obsessively critical attitude.

Both the golem and Adam Kadman, the Primeval Man (this time swinging from a helicopter), figure once again in **Kabbalah/Kabul.** *Could you discuss this?*

The figure hanging from the helicopter belongs to the primal man, Adam Kadman. He is swinging from a helicopter that has been used in the Afghanistan war. Perhaps Adam Kadman represents the redemption of mankind when he spreads the altruistic messages. On the website, continuing on to the second page, Adam dissolves into the Tree of Life. The Tree represents universal values which can be accessed by linking to a related body part depicted among the stem cells.

In *Kabbalah/Kabul,* the golem represents the moral perfection of an artificial being attained by modern technology. After the golem is "perfected," it is morphed with the mutagenically altered blowfly for the purpose of distributing altruism in outer space. The golem becomes my alter ego, as I hope it would be for others. This work was inspired by a SETI (Search for Extraterrestrial Intelligence) workshop for the purpose of designing a plan for communicating altruisms into outer space.

In this last bioweb work, **Kabbalah/Kabul,** *microbiological systems contrast with the vast expanse of space; and the terrible social implications of war meld with references to aliens with extraterrestrial intelligence. Although enigmatic contradictions recur throughout your works, here the contrasts are extreme. And now, the idea of redemption morphs into the dream of altruism. What are your thoughts on this?*

As the transmutations most likely to survive are the positive ones, redemption and altruism reflect positive selection. From the nuclear bombardment of the Philosopher's Stone, a noble metal was realized; from the detritus of the blowfly, an altruistic golem was molded. May regeneration into a peaceful outer space emerge from decay of terrorist Earth.

Notes

1. 1995 saw the production of *Smell Your Destiny,* a parodic interactive web art project much in the same vein as *The Transgenic Bagel.* In this artwork, Rapoport posited that traits historically considered undesirable are now considered more desirable. For example, aggressiveness and competitiveness were once considered negative traits when displayed by women, but now such traits are seen as a key to success in the corporate environment. Rapoport proposed that these new values and traits might be administered to a population by means of aromatherapy. She introduced the idea that pharmaceutical pills that carried specific favorable traits could be fed to fish living near or within a given society. After consuming the pills, the fish would give off a "stink" that would permeate the air and be inhaled by the inhabitants of the surrounding community, thus transmitting the desired traits/societal values to its citizens. This process was historically specific, in that pills fed to fish in the Qumran region in 150 BCE would have been different than those fed to fish today. This piece displayed Rapoport's characteristic love of word play...for instance, the names of the pills given to the fish were all puns on common over-the-counter products, e.g., "Anvil" (for Advil), All-to-rest (for Allerest), Chums (for Tums), My-Thrill (for NyQuil), Contract (for Contact), No-mor-fussin (for Robitussin), and Re-lax (for Ex-Lax).

2. Cecil Roth, ed. *The Standard Jewish Encyclopedia* (Encyclopedia Publishing Ltd., 1959), 26.

Sonya Rapoport: A Woman's Place Is in the Studio

Anu Vikram

Why consider the work of Sonya Rapoport now? The life experiences and artistic trajectory of this pioneering artist touch on three stages of feminism in the twentieth century. In Rapoport's work, connections can be found with artists from her own generation, with artists born after World War II, and with younger artists emerging after 1990. This essay will explore some of the relationships between Rapoport's practice and that of her peers and inheritors, among them feminist artists working with systems and media in a Conceptual manner. By exploring relationships such as these, much can be learned about the evolution of women's roles across generations, informing feminist and artistic concerns independently.

Sonya Rapoport defies any simple understanding of the term *feminist*. Born in 1923, she gave birth to the first of three children not long after completing her MFA from the University of California, Berkeley, in 1949. As a housewife in Berkeley, she was not involved in any sort of political protest, though as a UC Berkeley alumna she was certainly aware of the historic events that unfolded in her backyard. Blending the pragmatism of her peers, informed by the hardships of the Great Depression, with the utopian impulses of the 1960s, she arrived at a more personal approach to political concerns. In addressing concerns of feminism and social welfare in a nuanced and open-ended way that eschews propaganda, Rapoport's work since the late 1960s prefigures how younger artists have approached these issues in recent times.

Rapoport's individual practice as an artist both reflects and predicts trends in contemporary art made by women during her lifetime thus far. Never at the center of the art world, she has always been a presence, exhibiting with notable artists from her own Abstract Expressionist generation, as well as Conceptualists, performance artists, and interactive artists. Some examples include Elmer Bischoff, Joan Brown, John Baldessari, Eleanor Antin, Jenny Holzer, Hanne Darboven, and Vito Acconci.

Sonya Rapoport at the Legion of Honor, San Francisco, with two of her abstract paintings, 1963

At UC Berkeley, Rapoport studied under students of Hans Hofmann including Erle Loran and Margaret Peterson and alongside Jay DeFeo, a couple years her junior.

Initially a painter, she developed a Conceptual approach to art practice in the 1960s and 1970s. Her affinities with several major movements of American art in the twentieth century—the Berkeley School of Abstract Expressionism, Conceptual and systems-based art, distributed and networked media art, and performance as a social medium—underscore Rapoport's status as an underrecognized pioneer of late-twentieth-century art in California and the United States, and internationally as well.

Like DeFeo with *The Rose*, a massive painting that evolved between 1958 and 1966 through continual reworking and reconfiguration, Rapoport is obsessive in revisiting her work. From 1979 to 1984, she produced eleven iterations of her major work *Objects on My Dresser* (see Plates 7 to 24). These artists' practices are linked in part by the fact of their in-home studios (a circumstance shared by many women artists, although far from unique to women), which allows for the kind of constant living with the work that an intricately evolving process of reexamination requires. The conflation of domestic space and Process art that resulted in *The Rose* has been well documented, most notably in Bruce Conner's film *The White Rose* (1965), which shows the artist's apartment being cut apart to release the massive painting that is nearly inextricable from its architectural context. Rapoport's work similarly blends these elements, though with very different results.

For California artists of the feminist generation, such as Miriam Schapiro and Judy Chicago, core imagery like that of *The Rose*'s central radiating form was a visual

91

sign meant to represent a crystallized, female-specific frame of reference. This motif has since been the subject of much debate among feminists, as challenged as it is embraced for its essentialist and homogenizing symbolism. DeFeo and Rapoport were among those who resisted such simplification for political ends. Even before Schapiro gave a name to *femmage*—the appropriation of domestic materials and feminine motifs in postwar art—Rapoport was exploring, and feeling constrained by the limitations of, essentialist female symbology. Her use of patterns and materials culled from the domestic sphere in the 1960s, like her explorations of Abstract Expressionism in the 1950s, contributes to Rapoport's unique trajectory as an artist who moves freely between important and disparate movements in her lifetime.

For Rapoport, the form of a central core from which axes emanate is linked to the flow of information over networks, in a Conceptual systems framework that opens to association and interpretation from the audience as well as the artist. Multiplicity counteracts essentialism, as the radiating core replicates itself at various points along the network where information branches afresh. The central node or anchor point gives rise to social relationships that extend from it in all directions. Those relationships are

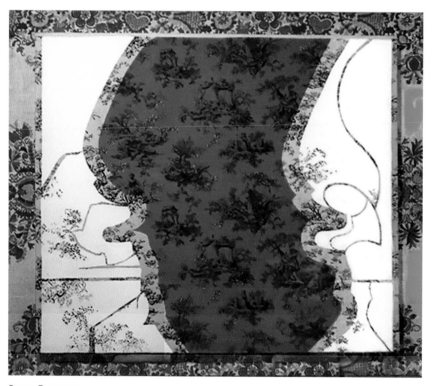

Sonya Rapoport
Red Graze, 1967
Silkscreen on fabric, acrylic paint, one canvas attached to another
42" H x 48" W

articulated as the connections between words and images, a cognitive pairing function that represents our ability to make links between concepts through social action.

Louise Bourgeois, though born a decade earlier, is another artist whose works and circumstances mirror Rapoport's own in some ways. The idea of the mother as a social node, whether cast in a positive or a negative light, is central to both artists' lexicons. In Bourgois's works, such as *The Nest* (1994), the mother spider is a physical anchor for her children, whom she simultaneously shields and dominates. The version of *Objects on My Dresser* exhibited at 80 Langton Street in San Francisco in 1980 included a "mother-daughter NETWEB of image-word relationships" marked by a spider at the center, indicating the mother. The implication in both works is that the mother builds the web that undergirds society. Bourgeois's sculpture formally relates that social function to the patriarchal implications of institutional architecture, while Rapoport uses it conceptually, suggesting that the connections between image and language that form the building blocks of our relationships are linked by webs of information spun by the mother.

Louise Bourgeois
The Nest, 1994
Steel, 101 x 189 x 158 inches (256.5 cm x 480 cm x 401.3 cm)
Collection of San Francisco Museum of Modern Art, purchased through the Agnes E. Meyer and Elise S. Haas Fund and the gifts of Doris and Donald Fisher, Helen and Charles Schwab, and Vicki and Kent Logan. © Louise Bourgeois Trust/VAGA, New York, NY. Photo: Courtesy Musée d'Art Moderne de la Ville de Paris.

Louise Bourgeois famously drew on family history for much of her subject matter throughout her long career. Her use of fabric in sculpture was inspired by her parents' work in textiles, while her *Cell* installations brought domestic space into the realm of the art gallery. Sonya Rapoport likewise brought the materials of her domestic realm into her artwork, appropriating into her drawings graphs and computer printouts that were byproducts of the scientific research in which her husband and daughter were engaged. Her use of space in installations such as *Objects on My Dresser* and *Brutal Myths* (see Introduction) is meant to create a comfort zone of domestic space within the public, social space of the art gallery.

Like Rapoport, Bourgeois raised children and ran a household while pursuing her career as an artist. Unlike Rapoport, Bourgeois married within the art world, so that when her children were grown and she was free to pursue her art career more actively, she already had access to a network of tastemakers. For Rapoport, marginalization has been as much a constant of her career as her position on the leading edge of new ideas. As a Bay Area Expressionist, she was embraced by her artist peers but didn't see much outside recognition. Not brought up to call attention to herself, she was ill equipped for the postwar romance with the artist as an emblem of individual,

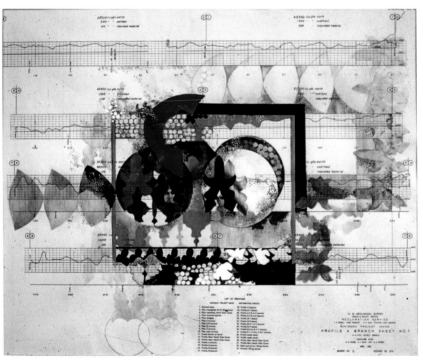

Sonya Rapoport
Survey Chart #14, 1971
Gouache and graphite on a geologic survey chart
18" H x 22" W

94

masculine genius and ego. Nonetheless, Rapoport's work in this period is significant and valued by collectors even today.

Rapoport began to focus on drawing largely because she needed to work with available materials, to conserve resources and space as she moved away from painting. Purchasing an antique architect's desk, she found it was filled with survey charts of the US Midwest and Far West, including sites of wartime internment camps for Japanese Americans. She began to draw on these, using biomorphic forms based on her own private Nu Shu language. Intuitively, and coming from a formal rather than a conceptual starting point, Rapoport happened upon a visual lexicon in this period of the late 1960s that took apart the implicit associations we make with the forms of language, maps, and charts—the systems we use to order the world around us.

Rapoport's shift in this period was informed by the detritus of her domestic life, in this case computer printouts of statistical data analysis from her husband's and daughter's scientific research (at UC Berkeley and UC Davis, respectively). At first the numerical data was merely visual information for the artist to extrapolate, but following the survey-charts work, Rapoport began to make connections between the data on the page and the images and text she rendered in its midst. She began to develop a collaborative process, partnering with researchers including botanists and chemists, anthropologists, psychologists, and social scientists to create works that used up-to-date research information from these specializations to inspire larger connections between science and society, anthropology and current events, psychology and social connectedness. From there, it was a short leap for Rapoport to open not only the concepts but the forms of her work to audience participation, interaction, and influence.

As she raised a family, continuing to stay on top of new developments, to make art in her home studio, and to exhibit, Rapoport found herself bypassed in the mainstream art world by younger artists who declared artistic invention and child-rearing incompatible. Unlike Rapoport, who was married by then, women born in the 1940s who chose to be artists rarely had children. One notable exception was Mary Kelly, a Conceptual systems artist who bridged feminist critique of social and familial expectations with the logical universalism of Conceptual art. Rapoport's practice overlaps with Kelly's in the rigorously intellectual approach that both artists bring to their investigations of family bonds, and in the feminist sensibility that both artists apply to constructions of masculine identity and feminine identity in equal measure.

Social practice is a mode of interactive art making, in which political concerns are articulated and enacted through the bodily participation of the audience. Sonya Rapoport and Mary Kelly were among the feminist Conceptual artists that pioneered these strategies in the 1970s and 1980s, before Relational Aesthetics reified social encounters in art galleries into static, collectible artifacts in the 1990s, and before a generation of artists raised on the Internet and distributed gaming reinvigorated interactive arts in the past decade. The collective political action which inspired Rapoport's and Kelly's early investigations of interaction in the art context was rooted in the protest culture of the 1960s and 1970s, inspired by activist theater in the public sphere and by the notion that "the personal is political." For both Rapoport and Kelly,

Mary Kelly
Post-Partum Document.
Documentation IV:
Transitional Objects, Diary
and Diagram, 1976
Perspex unit, white card,
plaster, cotton fabric, 1 of
the 8 units, 14" H x 11" W
(28 x 35.5 cm) each
Collection, Zurich Museum.

Sonya Rapoport
Manhood Manifesto (American
Bison/44th President of the
United States), 2009
Website intervention

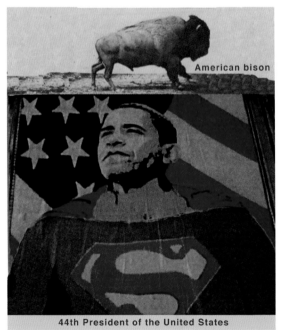

this meant that introspection—considerations of personal history, family, and the domestic sphere—could be invested with significant communicative power. Coming from an understanding of Process art, both artists recognized collective activity as another form of process, exposing the systems that underpin social interaction.

Another affinity between Rapoport's practice and Kelly's lies in both artists' historically informed points of view. Mary Kelly has mined classical antiquity, seeking out the structures of patriarchal hierarchy in Western cultures at their source. Rapoport has likewise delved into the medieval European origins of science in alchemy and sorcery, as well as ancient African and Native American traditions, seeking out the sources of cultural normatives around gender, family, and social responsibility. Ever the rigorous intellectual, Rapoport has worked closely with leading academics in the fields of anthropology, social science, psychology, chemistry, botany, and computer science to develop her investigations. Furthermore, Kelly's *Post-Partum Document* (1973–79) is an early feminist inquiry into the construction of masculine identity. Concurrently, Rapoport applies feminist thought to constructions of manhood in works such as *Make Me a Man, Make Me a Jewish Man* (see Hava Rapoport chapter), and *Brutal Myths*.

Rapoport's approach to academic disciplines is that of the informed amateur, a persona that reappears at the end of the twentieth century as artists avail themselves of the barrage of information now available to them via the Internet. The artist as amateur is no dilettante—rather, she is able to immerse herself in a host of disciplines, while remaining apart from their entrenched doctrines and prejudices. She becomes an interpreter between the academy and the general public, making rigorous concepts accessible to a broad audience through investigative and exploratory interventions.

The role of the artist in the postwar era is an ongoing performance, requiring an enormous commitment of time and energy to cultivating a large social network that is narrow in both its interests and its points of reference. For Rapoport, who has always preferred to focus her energy on satisfying the needs of her artwork and her personal life, the part of the celebrity artist holds little appeal. Rapoport's gift is her ability to disappear within the work, so that her presence is felt in the underlying systems that govern her uses of information and interaction. The audience member manipulates the forms of a work such as *Objects on My Dresser* or *ShoeField* (1982–88; see Plate 25 and Plate 26) through his or her participation, so that the end result is a kind of collaboration between artist and visitor.

One inheritor of this social approach to art practice is Brazilian artist Rivane Neuenschwander, whose works, like Rapoport's, propose a gamelike situation for participants in which their own interpretations of the questions posed by the artist become the material for future iterations of the work. In *I Wish Your Wish* (2003), Neuenschwander covers a wall with ribbons bearing printed wishes, which visitors tie around their wrists in the hope that the wishes will come true. The public is invited to contribute their own wishes to a book, which will become the material of future installations. This format echoes Rapoport's *ShoeField*, in which visitors who

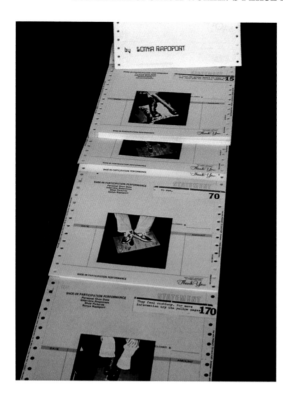

Sonya Rapoport
Shoe-In (participation
component of *Why I Wear These
Shoes?*), supporting document
from *ShoeField*, 1982
Collage on business forms
476" H x 7.5" W

were asked for the histories of their shoes contributed data that the artist revised and updated for each installation of the project. The accumulated shoe data—which Rapoport translated using a notation system derived from classification systems applied to archaeological finds at Pueblo Indian sites—becomes a collective portrait of the participants.

This action, while seemingly innocuous, is in fact quite political, evoking serious questions about gender, consumption, and self-image. Distributed, participatory performance art as collective political action is a strategy employed by Third Wave feminist artists such as Sharon Hayes, who like Sonya Rapoport conflates the personal and political in works such as *Revolutionary Love* (2008). The text of this work, performed in public by a diverse group of gay, lesbian, and transgendered participants on the occasion of the Republican National Convention, is infused with double meanings which evoke both personal passion and political fervor. Rapoport's gesture, while less overtly engaged with the hot-button issues of the day, is also radical in its reconfiguration of gender archetypes through dress and participatory action. Additionally, Hayes's layered process, including text, performance, and time-based media, parallels Rapoport's pioneering work in intermedia.

The impact of an artist like Sonya Rapoport—who embraced video and digital technologies both for documentation and as the medium of her work from the

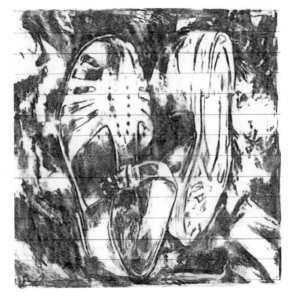

Sonya Rapoport
*Bonito Rapoport Shoes:
Rapoport's Jellies (detail)*,
1978
Transfer image on
continuous computer forms

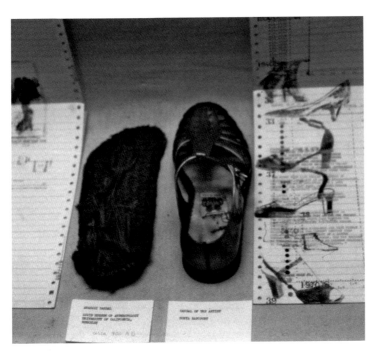

Sonya Rapoport
*Bonito Rapoport Shoes: Anasazi Sandal (c. 1000) and Rapoport's Jellie
Sandal (c. 1978)*, 1978
Drawings on printout
Installation at the Donnell Public Library, New York

moment that these methods became available to artists—on contemporary intermedia practices cannot be overstated. More importantly, what sets Rapoport apart from many of her video and interactive art contemporaries is the ease with which she has moved from drawing and painting to mass media and back, throughout her career. This commitment to explore both traditional and new media is unusual in an era when "media artists" have been confined to a separate (and largely unequal) narrative within the context of contemporary art history.

Nonetheless, such an approach has been embraced by artists coming of age in the past decade, such as Rapoport's fellow UC Berkeley graduate Desirée Holman. In recent works such as *Reborn* (2009) and *The Magic Window* (2007), Holman begins with handmade sculptural objects, which she then activates through live performance with actors. The performances are captured as video, exhibited in multichannel installations, while production stills are again translated by the

Sonya Rapoport
(in)AUTHENTIC (hair/phallic), 2008
Transfer images on acetate
11" H x 8.5" W

artist's hand into exquisite drawings in colored pencil on paper. Rapoport's practice of using photographic transfer as well as freehand drawing in works such as *Kiva-Studio* and *Chelate* (1981; see Plate 23), an artist's book that furthers the lines of thought originated in *Objects on My Dresser*, prefigures Holman's movement between handmade and mass media.

Another contemporary UC Berkeley graduate, Shana Moulton, uses both live and videotaped performance as well as sculpture in works that investigate links between New Age spirituality, consumerism, and feminist consciousness with humor. Moulton's videos tell the story of Cynthia, a dissatisfied housewife with a passion for consumer products, who is on a never-ending quest for self-actualization. Her mundane circumstances are routinely transformed into exhilarating, psychedelic experiences by the most commercial self-help activities, such as a tai chi video featuring geriatric actress Angela Lansbury (*Feeling Free with 3D Magic Eye Poster Remix*, 2004). The liberation experienced by Cynthia through these "inauthentic" spiritual means is of a piece with Rapoport's *(in)AUTHENTIC,* in which the artist considers "the female as a displaced person," appropriating traditional Nigerian hair-braiding styles as a lexicon of emotional engagement for women whose experiences have historically been deemed too insignificant or imprecise for serious consideration.

Easy and perhaps superficial access to a range of global cultures is a condition of our current, wired age, and this circumstance provides fodder for contemporary artists. Sonya Rapoport's eclectic artistic practice predates and in many ways predicts the Internet age, as she has culled from a range of cultural and historical sources throughout her career. This mode of working was once dismissed as inconsistent or inappropriate—an artist of Rapoport's generation was expected to master one or a few media and ignore all others, and similarly was discouraged from investigating cultures not her own, in a backlash against the indiscriminate appropriation of "primitive" motifs by early twentieth-century modernists. Today it seems prescient, and inevitable, that an artist with access to information from fields as diverse as biochemistry, psychiatry, and anthropology and cultural material from far-flung places like Nigeria, central Europe, and pre-Columbian America would cull and remix from all these sources.

Why consider the work of Sonya Rapoport now? For emerging and midcareer artists using multimedia in a feminist vein, Rapoport is a maternal forebear whose diverse practices and stalwart commitment to balance art and family provide necessary guidance. Between Rapoport's generation and these artists' own, a mindset that denied female artists a full personal life took hold, as women in the 1970s and 1980s observed that they could succeed on the same terms as men as long as they adopted a monastic commitment to their work above all else. Sonya Rapoport's commitment to her professional, cutting-edge artistic practice has been evident for nearly sixty years, during which time she has also been wife, mother, and grandmother. Female artists entering the field today have observed both the gains and the sacrifices made by their mothers, and Sonya Rapoport provides an object lesson in balance that is much needed within the contemporary art landscape today.

References

Bourgeois, Louise. *Destruction of the Father/Reconstruction of the Father: Writings and Interviews, 1923–1997.* Ed. and with texts by Marie-Laure Bernadac and Hans-Ulrich Obrist. Cambridge, Mass.: MIT Press, 1998.

Gouma-Peterson, Thalia. *Miriam Schapiro: Shaping the Fragments of Art and Life.* New York: Harry N. Abrams, 1999.

Green, Jane, and Leah Levy, eds. *Jay DeFeo* and *The Rose.* Berkeley: Univ. of California Press, 2003.

Kelly, Mary, et al. *Mary Kelly.* London: Phaidon, 1997.

On the (R)evolution of Art and Science and One Sonya Rapoport

Walter H. Moos, Susan M. Miller, and Sarah R. Moos

We cannot do justice in a short dialogue to the creativity, innovation, and novelty of the work of Sonya Rapoport, especially given her continuing and always fresh and new successes marrying art and science. But we will try to at least scratch the surface in the following paragraphs.

Getting two disciplines to work together, such as the important collaboration of sciences such as chemistry and biology, is hard enough. How could anyone ever marry a humanities discipline like art with science, technology, engineering, and math, and then say "art and science" in the same breath? More easily than you might think, given Sonya's pioneering efforts!

Today, the combination of art and science is appearing next door and around the world. Look at what James Madison University has been doing of late (see http://www.jmu.edu/jmuweb/general/news/general11447.shtml). Note the special lecture by one of the decoders of the human genome, physician-scientist Francis Collins, who is the current director of the National Institutes of Health and who has also written a book on religion and science, combined with Liz Lerman's dance troupe performing *Ferocious Beauty: Genome.* But we digress….

Despite common misconceptions of evolution, in Charles Darwin's uncovering of the "survival of the fittest" in the mid-nineteenth century it is more accurate to conclude that those most responsive to change are the ones who survive and thrive. Exactly this theme of adaptation is evident in the way Sonya Rapoport's career developed, as the underlying details of genes and evolution are intrinsic to her pieces *(vide infra).*

Fast forward to the mid-twentieth century, when Sonya Rapoport began to establish herself as a promising young painter with innovative ideas on how to express her insights through the underlying tools of abstraction (note her exhibition at the

Professor Henry Rapoport with Sonya's art behind him at UC Berkeley, 1988

California Palace of the Legion of Honor in the early 1960s). At the same time the fundamentals of the structure of DNA—the double helix—were being elucidated by Francis Crick, Rosalind Franklin, James Watson, and other great scientists of a bygone era, during which time Sonya's husband, Henry Rapoport, was also gaining tenure as a faculty member at the University of California, Berkeley, in chemistry. Much as Sonya uses metaphors in her work, we must point out that the helix of art and science had already entwined Sonya, Henry, and many of their friends and colleagues in its powerful grip.

Naturally, and sometimes supernaturally, Sonya's work continued to evolve, moving from a static canvas that nonetheless appeared alive to laboratory illustrations using scientific equipment and data traces or computer printouts. Then Sonya began to explore installations that provided an interactive format to delve into the not-so-obvious reaches of human psychology. Witness *ShoeField,* which is being revived as we write, and where, as you might expect, personal reactions and the underlying biochemical reactions of experience are driven by the genes with which we are born and the environmental factors that can both add to and modify human perception. In *ShoeField* the perceptions of the participants are modified by their proximity to each other as they wait in line upon entering the site. Their "neighbor" responses to the show questions are manifested in the resulting force-field/*ShoeField Map.*

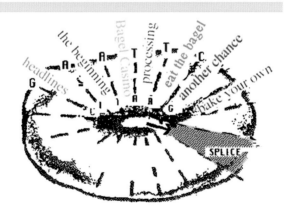

Sonya Rapoport
The Transgenic Bagel (Watson and Crick), 1993–96
Website
Size variable

Onward Sonya evolved, contributing to *Leonardo* (the journal of the International Society for the Arts, Sciences and Technology), now exploiting a different genetic code, a binary one with 0's and 1's, with different evolutionary pressures than the natural world. Along the way, she sprinkled in a little Jewish mysticism, sex and gender issues, the Kabbalah ritual of permutation and transmutation, and the search for extraterrestrial intelligence (SETI). What breadth—there are no bounds to her creativity.

In her fascinating works *Redeeming the Gene; Molding the Golem, Folding the Protein* and *Digitizing the Golem: From Earth to Outer Space* and *Kabbalah/Kabul: Sending Emanations to the Aliens* (see Plate 28), Sonya came full circle to the "Tree of Life," including the circular DNA of mitochondria, our biochemical powerhouses, "mitoDNA" being inherited only from the mother, and with mitochondria often governing cellular energy and life and death. Of course, Jewish heritage had been traced through maternal lines since the beginning of time, thousands of years before mitoDNA was discovered. As icing on the cake, Sonya was again well ahead of her time with her creation of the transgenic bagel and neurotic genes, "the splice of life," even seeing her work published tongue-in-cheek in a top scientific journal, *Nature Biotechnology,* just before the new millennium.

So where does this leave us? Let's conclude by tying together biosciences, systems biology, and Sonya's many contributions. In the field of biosciences, systems biology involves the study of complex interactions and detailed pathways to understand the big picture. Systems biology integrates many approaches, including genomics, proteomics, biochemistry, and medicine, and thereby enables the development of new ways to prevent, diagnose, and treat disease. Taking the field from theory to data to practical applications, we see clearly that the whole can be larger than the sum of its parts.

Through the different phases of Sonya's career, she has applied a systems approach over and over again, and yet each time in new and different ways. She continually merges and commingles art, design, religion, and science. Taken as a whole, her work uncovers numerous elements of systems that a scientist will understand: alchemy, biorhythms, computers, genes and proteins, laboratory glassware, spectroscopy, life and death, mitochondria, organic chemistry and its three-dimensional molecular world, pharmaceuticals and pills, and the search for extraterrestrial life. Isn't it fascinating what emerges when supposedly unrelated fields come together? Once again, the whole is greater than the sum of the parts! Thank you, Sonya, for bringing us all together, forever.

Afterword: Conflict of Interest

Roger Malina

As a working scientist I am accustomed to declaring my conflicts of interest before I serve on peer review panels or juries—indeed the ethos of science seeks to disconnect scientific discovery from personal context. Art, of course, is another matter, where "conflicts of interest" drive artistic creation and motivate viewers' aesthetic curiosity. So, it is with a flourish that I declare my conflict of interest: I have known Sonya Rapoport's work for many years, and have had the pleasure of working with her at *Leonardo*/ISAST (the International Society for the Arts, Sciences and Technology). We've met in her studio innumerable times, and she has often showed me her work in progress, most recently her work using the Web, such as *Smell Your Destiny* (see Plate 29) and *Kabbalah/Kabul* (see Plate 28).

Rapoport is an exemplar in an emerging movement in the arts that is sometimes called "artscience." This artistic movement seeks to appropriate contemporary science and technology—not to explain or communicate science, but rather to create the new artistic visions that will root tomorrow's innovations in science, art, and other fields. Rapoport's use of science and technology is never literal: it combines ancient texts and deep personal and cultural meaning with new scientific discoveries that relate to them. She seeks to create new conditions for the emergence of meaning by way of "autopoietic" acts. Autopoietics has been a powerful idea in the community of artists whose work links to contemporary science and new technologies: derived from autopoiesis, a term in biology, autopoietics seeks to elucidate the ways in which self-organizing processes contribute to living systems. Her early appropriation of computer printouts from her husband's laboratory (Henry Rapoport was an organic chemist well known for synthesizing biologically important molecules); her interest in the periodic table of elements; and her more recent fascination with genetics as cultural code all illustrate her interest in systems.

Rapoport has continually employed new methods of artistic creation that combine the intimate and the public in disarming ways. Scientific fact, feminism, and

technological innovation come together in her Conceptual art, and in her evolving career she has relied on a bewildering variety of physical supports. Gyorgy Kepes, in *The New Landscape in Art and Science* and other books, boldly integrated scientific instruments into artistic practice. In this tradition, Rapoport has appropriated the scientific method itself as a form of artistic practice. Not only does she use scientific apparatuses for nonscientific purposes (the computer, biofeedback, genetic mapping), but she also uses methods of scientific analysis (charts, graphs, questionnaires) to illustrate and to explicate.

The scientific method itself is not a stable artifact: it has evolved over the centuries as scientists have developed new ways to construct the testable descriptions that become scientific explanation. For instance, the computer has had a number of epistemological impacts. In some complex systems that lack mathematical formalism, a computer can now accurately predict behavior based on testable simulations. In recent years disciplines that were data-poor often find themselves data-rich as a result of "big data" approaches to pattern recognition and prediction. It seems to me that Rapoport's work—with her early adoption of computers and new media, and later the Internet and the Web—in some ways anticipated or interpreted this evolution and even reveals the scientific method as a *cultural* object.

A number of sociologists of science have argued that we need to embed science in society, thereby creating a "socially robust science," as Helga Nowotny calls it. She has specifically called for new, "mode 2" (interdisciplinary and context-driven—versus investigator- and discipline-driven) approaches in the biological sciences and genetics. Similarly, Indian philosopher of science Sundar Sarukkai, in an examination of the ethics of scientific curiosity, has attacked the idea that scientific inquiry can be separated from human nature: it is meaningless and theoretically undefendable to separate the pure from the applied sciences. A number of Rapoport's works, *Make Me a Man* to name but one, tackle these issues head-on, unpacking the tangled web of science and sexism, science and military, and science and cultural mythology. Rapoport seeks everywhere to reveal the objective connections that deny such dichotomic separations. These "conflicts of interest" become mechanisms for cultural—and human—survival.

References

Kepes, George. *The New Landscape in Art and Science.* Chicago: Paul Theobald, 1956.

Nowotny, Helga, Peter Scott, and Michael Gibbons. *Re-Thinking Science: Knowledge and the Public in an Age of Uncertainty.* Cambridge: Polity Press, 2001.

Nowotny, Helga, and Giuseppe Testa. *Die gläsernen Gene, Die Erfindung des Individuums im molekularen Zeitalter.* Berlin: Suhrkamp, 2009.

Sarukkai, Sundar. "Science and the Ethics of Curiosity. *Current Science* 97, no. 6 (2009), 756–767.

Contributor Biographies

Terri Cohn is a writer, curator, and art historian and considers these facets of her career to be intertwined through her research and writings in the areas of conceptual art, public art, and socially engaged art practices. She was a contributing editor to *Art-week* magazine for twenty years and has contributed to numerous journals, five books, and dozens of exhibition catalogs. A curator for more than thirty years, during 2005 Terri served as interim Matrix curator at the UC Berkeley Art Museum and currently works as an independent curator. A faculty member in the School of Interdisciplinary Studies at the San Francisco Art Institute, she has done research and writings and has given talks at museums and universities ranging from the San Francisco Museum of Modern Art and Guggenheim Museum, New York; to the Social Sculpture Research Unit, Oxford Brookes University, England; and Columbus College of Art and Design, Ohio. Her residencies have included the Headlands Center for the Arts (affiliate, 1995–97) and Vermont Studio Center (artist grant awards, 2009 and 2011). She has served as a board member for the Djerassi Resident Artists Progam and was a founding member of the advisory board for the Art Monastery, Italy.

Hava Rapoport is the only daughter of Sonya and Henry Rapoport, oldest of their three children. She was born and grew up in Berkeley, California. She married Elias Fereres, with whom she has two daughters, Sonia (named for her grandmother) and Sol. Hava has always had a strong interest in biological science, obtaining a BA in biology at UC Santa Cruz and an MS and PhD at UC Davis. She moved with Elias to Cordoba, Spain, where she is now a tenured scientist in the Scientific Research Council of Spain (CSIC), working in the Institute for Sustainable Agriculture on horticultural research, specifically on crop growth and development with emphasis on the olive tree. Hava is also strongly moved and inspired by form, influenced by mother Sonya from an early age, an interest which she expresses both in her scientific studies of plant shape and structure and in her quilt-making hobby.

Richard Cándida Smith is a professor of history in the Department of History at the University of California, Berkeley, where he teaches intellectual and cultural history of the United States. He is the author of *Utopia and Dissent: Art, Poetry, and Politics in California; Mallarmé's Children: Symbolism and the Renewal of Experience;* and *The Modern Moves West: California Artists and Democratic Culture in the Twentieth Century;* and the editor of *Art and the Performance of Memory: Sounds and Gestures of Recollection* and, with Ellen DuBois, of *Elizabeth Cady Stanton, Feminist as Thinker.* He is currently working on a book on the development of inter-American cultural markets. He is the director of the Regional Oral History Office at the University of California, Berkeley. He has directed oral history projects since the 1970s, is a past president of the Oral History Association, and has been active in the Working Group on Memory and Narrative, an international, interdisciplinary forum of scholars working in oral history and related disciplines. Among recent projects are interviews with fifty-five directors, curators, trustees, and other staff members of the San Francisco Museum of Modern Art.

John Zarobell is an assistant professor and the program director of European studies at the University of San Francisco. He formerly served as assistant curator at the San Francisco Museum of Modern Art and associate curator at the Philadelphia Museum of Art, where he organized exhibitions such as *Frida Kahlo; Manet and the Sea; Renoir Landscapes;* and *Art in the Atrium: Kerry James Marshall.* He is a regular contributor to the Web-based journal *Art Practical,* has contributed to numerous exhibition catalogues, and has published in *Art History, Nineteenth-Century Art Worldwide,* and the *Berkeley Review of Latin American Studies.* His book *Empire of Landscape,* published in 2010, concerns the intersection of colonial politics and landscape art in nineteenth-century France.

Anna Couey works at the intersection of art, communications, information, and social justice, using participatory media tools, story-collecting methods, and community-building processes to reimagine and restructure power. During the 1980s and 1990s, she helped develop art telecommunications projects such as the Art Com Electronic Network and Arts Wire, as well as producing temporary cross-cultural communications events as social sculpture. Since the mid-1990s, Anna has applied social sculpture strategies outside the art world, collaborating with alternative media makers; librarians, educators, and youth; and poor and working-class communities of color organizing for social justice. Her communication sculptures have been presented on the Internet, at the Interactive Telecommunications Program at New York University, the International Symposium on Electronic Art, and SIGGRAPH.

Judy Malloy is an artist and writer whose work has been exhibited and published internationally at venues including the San Francisco Art Institute; Tisch School of the Arts, NYU; Sao Paulo Biennial; Los Angeles Institute for Contemporary Art; National Library of Madrid; University of California, Berkeley; Houston Center for Photography; Institute for Contemporary Art New Orleans; San Antonio Art

Institute; Visual Studies Workshop; Walker Art Center; Eastgate Systems; E. P. Dutton; Tanam Press; Springer-Verlag; the Boston Cyberarts Festival; MIT Press; The Iowa Review Web; and the National Endowment for the Arts website. Her recent work *where every luminous landscape* was short-listed for the Prix poesie-media, France (2009), as well as featured at The Future of Writing, University of California, Irvine, on *Cover to Cover* on KPFA radio, and at the E-Poetry Festival in Barcelona.

A pioneer on the Internet and in electronic literature, Malloy wrote and programmed *Uncle Roger* (Art Com Electronic Network, 1986), one of the first hyperfictions, and in the ensuing years created a series of innovative works of e-literature that were published by Eastgate and on the Internet. In 1993 she was invited to Xerox PARC, where she worked with Pavel Curtis and Cathy Marshall as an artist in residence. She is the editor of *Women, Art, and Technology* (MIT Press, 2003) and the host of the *Authoring Software* project for electronic literature and new media. She is also the host of the *Art California* Web project, in partnership with the California Studies Association.

Meredith Tromble is an artist and writer working at the intersections of art, science, and technology. The most recent works in her wide-ranging oeuvre are performative interventions revealing psychological aspects of sustainability. She began her writing practice as a regular artist commentator for KQED-FM; she has since published in journals ranging from *Foundations of Chemistry* and *Leonardo* to *Artweek* and *Aspect* and cocreated and edited five art magazines and a book on Lynn Hershman Leeson published by the University of California Press. Her many public lectures include appearances at the Fine Arts Museums of San Francisco, Tate Britain, and the University of Caldas in Colombia. She is an associate professor in the School of Interdisciplinary Studies of the San Francisco Art Institute.

Ernestine Daubner is an art historian and art theorist, holding an interdisciplinary PhD in the humanities from Concordia University (Montreal, Canada), where she teaches in the art history department. Her research interests and publications focus on the intersections of art, science, and technology. She is currently mapping out the emerging field of contemporary art and biotechnologies in collaboration with *le Groupe de recherche en arts médiatiques* (GRAM) and the *Centre interuniversitaire en arts médiatiques* (CIAM) at the Université du Québec à Montréal, where she is adjunct professor. With Louise Poissant, she co-organized an international colloquium, *Art & Biotechnologies,* at the Musée d'art contemporain in Montreal in 2004 and coedited a book of collected essays, *Art et biotechnologies,* that includes a DVD-ROM anthology of approximately one thousand a-life and bioartworks (Presses de l'Université du Québec, 2005). A second volume is forthcoming. These activities have led her to research new media art in relation to the able and disabled body. In this regard, in November 2007, she co-organized a major international colloquium in Montreal entitled *Mobile/Immobilized: Art, Bioechnologies and (Dis)abilities,* for which the publication of a book of collected essays is planned. Ernestine Daubner has presented

her research in Canada, the United States, Mexico, and Brazil, as well as Europe, in Amsterdam, Geneva, Istanbul, Ljubljana, Lyon, and Prague. She is also the author of numerous publications on modern and contemporary art practices.

Anuradha Vikram is curator of the Worth Ryder Art Gallery and coordinator for the Graduate Lecture Series for the Department of Art Practice at the University of California, Berkeley. She is also a lecturer in art history for the Department of Art, College of Marin, in Kentfield, California. Recent exhibitions include *Sonya Rapoport: Pairings of Polarities,* cocurated with Terri Cohn for Kala Art Institute in Berkeley, as well as *Dislocated* and *Knowledge Hacking* at the Worth Ryder. Her writing has appeared in numerous print and online publications, including *Afterimage, Leonardo, Shotgun Review, Camerawork: A Journal of Photographic Arts,* and *Open Space,* the blog of the San Francisco Museum of Modern Art. She is a regular contributor to *Artillery* magazine. Past positions have included gallery director at Aicon Gallery in Palo Alto, program director at Headlands Center for the Arts in Sausalito, associate producer of the ISEA2006 Symposium and concurrent ZeroOne San Jose Festival in San Jose, California, exhibitions director at the Richmond Art Center, and studio manager for artists Claes Oldenburg and Coosje van Bruggen. She received an MA in curatorial practice from California College of the Arts, San Francisco, in 2005 and a BS in studio art from New York University, completed in 1997.

Walter Moos trained as a scientist with Sonya's husband and has led research and business divisions in pharmaceutical and biotechnology companies and nonprofit organizations. Walter and **Susan Miller** met at UC Berkeley and married, and she has held scientific faculty positions throughout her career. **Sarah R. Moos**, the evolutionary product of their marriage, is a graduate student in environmental design, also at UC Berkeley, carrying on Sonya's tradition of combining art and science in interesting new ways.

Roger Malina is an astronomer and editor. He currently is a member of the Observational Cosmology Group of the Laboratoire d'Astrophysique de Marseille and director of the Observatoire Astronomique de Marseille-Provence. His specialty is in space instrumentation; he was the principal investigator for the NASA Extreme Ultraviolet Explorer satellite. He also has been involved for twenty-five years with the *Leonardo* organization, whose mission is to promote and make visible work that explores the interaction of the arts and sciences and the arts and new technologies. He is executive editor of the Leonardo Publications at MIT Press. More recently he has helped set up the Mediterranean Institute for Advanced Studies (IMEDEA) and is cochair of the ASIL (Arts, Sciences, Instrumentation and Language) Initiative of IMERA, which hosts artists-in-residence in scientific research laboratories of the Marseille region.

Sonya Rapoport: Statements over Time

As individuals we are the cumulative sum of all our prior selves and iterations, and because I have spent so many years in this struggle to invent and share my work as a woman artist in a male-dominated art world, this list gives insight into my development and the abiding themes in my work:

1931: I want to be an artist; not the kind who paints pretty flowers. I want to paint ideas.

1937: Art gives one new ideas of creation and helps stress the beauty of imagination.

1977: A key to my work is the synapse of two unlikely entities, a dissident or serendipitous pair triggered into dialogue. Chaos emerges from the convolution of these polar entities until a meaningful resonance is resolved.

1978: My work is an aesthetic response triggered by scientific data. I use computer printouts for my format, a technological device having a beautiful form of its own, which allows me to bring science and technology into an aesthetic realm and make its visual and referential material accessible. I take particular delight in paralleling ancient mystical beliefs with their realizations in our day, due to our technological sophistication.

1980: Methods having the technological base of an advanced society reflect and form the structure of my work. The ideology of transmutation permeates its context. A confrontational merger of technological methods that reflect our society with everyday homely content of personal experience has the intent to awaken a new aesthetics of a universal nature.

1986: My work confronts human anxieties in a self-exploratory process. Viewer response takes place in an interactive environment that includes other cultures

and time periods. Because I feel a valid art form reflects the time, the place, and the concerns of the period in which it is created, I use the computer as a tool. With this tool, I can push further the concepts of interactive installation.

1989: My work is interactive, multidisciplinary, and focused on human responses. The execution of this material relies on current technological tools. In many cases through interactivity there is an audience reversal that creates content. My work describes and documents contemporary cultural patterns. For its structure I use pairings of these patterns with counterparts from ancient mythology, ancient cultures, and traditional systems such as alchemy and biorhythm.

2002: Since 1994, when I started creating artworks for Web viewing, I've shifted my conception of what comprises a work of art. The shift has evolved through my experience in working with image and text for expressing ideas in HTML format. Apparently this process of creating Web projects has unraveled layers of my identity. I am better able to organize ideas, references, and technologies for exploiting this message into richer, more direct, and more complex entanglements. A recent project, *Redeeming the Gene: Molding the Golem, Folding the Protein,* a mythic parody on genetic strategies and gender redemption, is an example of those sensibilities I accrued while working on the Web.

2003: In an interactive process using multimedia and digital art techniques I interweave social concerns, current events, and scientific advances metaphorically and humorously into computer-assisted art forms. Within the context of compara-tive cultures and diverse time periods I endeavor to erase political disparities that engender social prejudices.

2005: Commingling ancient mystical beliefs with modern technological sophis-tication, I reconstruct the evolution of four decades of transdisciplinary artworks that relate to the alchemical theme of transmutation, identity, and regeneration, culminating in recent work that attributes a soul to a golem. Today the spontaneous generation of a golem sustains itself as its robotic sibling.

2007: Within an interactive process of new media, multimedia, and digital art components, I interweave social concerns, current events, and scientific advances metaphorically and humorously.

2010-11: Reflecting on my past work I am currently re-exploring their basic structure while updating their content and processes, creating new Web-based blog entries that reflect our engagement in the arena of current global politics and attitudes.

Index

HEYDAY
into California

About Heyday

Heyday is an independent, nonprofit publisher and unique cultural institution. We promote widespread awareness and celebration of California's many cultures, landscapes, and boundary-breaking ideas. Through our well-crafted books, public events, and innovative outreach programs we are building a vibrant community of readers, writers, and thinkers.

Thank You

It takes the collective effort of many to create a thriving literary culture. We are thankful to all the thoughtful people we have the privilege to engage with. Cheers to our writers, artists, editors, storytellers, designers, printers, bookstores, critics, cultural organizations, readers, and book lovers everywhere!

We are especially grateful for the generous funding we've received for our publications and programs during the past year from foundations and hundreds of individual donors. Major supporters include:

Acorn Naturalists; Alliance for California Traditional Artists; Anonymous; James J. Baechle; Bay Tree Fund; Barbara Jean and Fred Berensmeier; Joan Berman; Buena Vista Rancheria; Lewis and Sheana Butler; California Civil Liberties Public Education Program, California State Library; California Council for the Humanities; The Keith Campbell Foundation; Center for California Studies; City of Berkeley; Compton Foundation; Lawrence Crooks; Nik Dehejia; Frances Dinkelspiel; Troy Duster; Euclid Fund at the East Bay Community Foundation; Mark and Tracy Ferron; Judith Flanders; Karyn and Geoffrey Flynn; Furthur Foundation; The Fred Gellert Family Foundation; Wallace Alexander Gerbode Foundation; Nicola W. Gordon; Wanda Lee Graves and Stephen Duscha; Alice Guild; Walter & Elise Haas Fund; Coke and James Hallowell; Hawaii Sons, Inc.; Sandra and Charles Hobson; G. Scott Hong Charitable Trust; Kendeda Fund; Marty and Pamela Krasney; Kathy Kwan and Robert Eustace; Guy Lampard and Suzanne Badenhoop; LEF Foundation; Kermit Lynch Wine Merchant; Michael McCone; Michael J. Moratto, in memory of Ernest L. Cassel; Steven Nightingale; Pacific Legacy, Inc.; Patagonia, Inc.; John and Frances Raeside; Redwoods Abbey; Robin Ridder; Alan Rosenus; The San Francisco Foundation; San Manuel Band of Mission Indians; Tom Sargent; Sonoma Land Trust;